GLASS, GILDING, & GRAND DESIGN
ART OF SASANIAN IRAN (224–642)

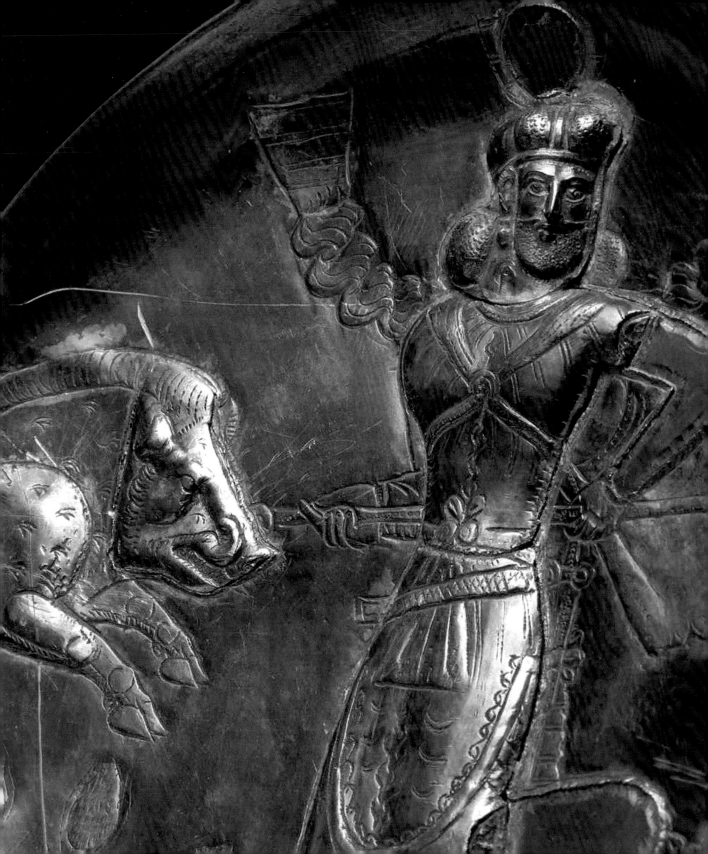

GLASS, GILDING, & GRAND DESIGN
ART OF SASANIAN IRAN (224–642)

Françoise Demange

Asia Society

This catalogue includes a selection of essays first published in the French catalogue *Les Perses sassanides: Fastes d'un empire oublié (224–642)* by Paris Musées / Éditions Findakly, Paris, 2006.

© 2007 Asia Society
New York, New York

Published in the United States by
Asia Society
725 Park Avenue
New York, NY 10021

Published on the occasion of the exhibition, "Glass, Gilding, and Grand Design: Art of Sasanian Iran (224–642)" at Asia Society, New York from February 14 to May 20, 2007. The exhibition was organized by the City of Paris, Musée Cernuschi, and Paris Musées in association with Asia Society, New York.

Exhibition made possible with the exceptional collaboration of the Musée du Louvre and the Bibliothèque nationale de France.

Exhibition made possible with major support from The Leon Levy Foundation; The Lee and Juliet Folger Fund; Lisina and Frank Hoch; and Sheila and Hassan Nemazee. Additional support was provided by Akbar Ghahary, Ph.D.; Amita and Purnendu Chatterjee; Jamshid and Mahshid Ehsani; The Soudavar Memorial Foundation; The Beningson Family, in Memory of Renee Beningson; and The Persepolis Foundation.

ISBN-10: 0-87848-106-0
ISBN-13: 978-0-87848-106-4

Library of Congress Control Number: 2006940646

Curator: Françoise Demange
Curatorial Advisor: Prudence O. Harper
Curatorial Consultant: Michael Chagnon

Project Manager: Marion Kocot
Copyeditor: Mary Chou
Designer: Peter Lukic
Printer: Friesens Corporation

Translation by EuroNet Language Services Inc.

Cover image: detail of Cat. 1, p. 36.

TABLE OF CONTENTS

PREFACE, Vishakha N. Desai 6

FOREWORD, Melissa Chiu 7

INTRODUCTION, Françoise Demange 9

THE SASANIAN WORLD, Rika Gyselen 13

THE RELIEFS OF TAQ-I BUSTAN, Françoise Demange 20

THE MOSAICS OF BISHAPUR, Françoise Demange 23

SILVER VESSELS, Prudence O. Harper 24

SASANIAN GLASSWARE, David Whitehouse 29

THE LEGACY OF SASANIAN ART, Michael Chagnon 33

SELECTED WORKS 35

FURTHER READINGS 47

PREFACE

Asia Society is delighted to present "Glass, Gilding, and Grand Design: Art of Sasanian Iran (224–642)." The exhibition and its accompanying catalogue demonstrate both the splendor of ancient Persia and the major achievements of the Sasanian Empire in the realms of government, commerce, and the arts. The content of this exhibition represents our continuing interest and dedication to understanding the histories and cultures of Iran; in 2003, we organized the exhibition "Hunt for Paradise: Court Arts of Safavid Iran, 1501–1576," which presented art from the beginning of the Safavid dynasty, a time of profound political change in Iran.

In view of current political and social tensions, there is no time like the present to engage in a deeper understanding of Iran's people and culture. The Sasanian arts of pre-Islamic Iran reveal a rich, cosmopolitan civilization that has deep resonance for the Iranian people even today. Through this exhibition and publication, as well as our programs in the fields of policy, business, education, and culture, we are pleased to be able to contribute to a greater knowledge and appreciation of Iran that can inform our current thinking about the region.

Vishakha N. Desai
President
Asia Society

We are seldom faced with the realization that our knowledge on a given subject is one-sided. During my first visit to Iran, I had such an experience, which greatly deepened my understanding of the region's history and culture. In school, I learned about the Persian Empire from sources such as the Greek historian Herodotus. Although my history teachers were careful to point out that he recounted Greek and Persian battles from the perspective of the Greeks decades later, one can't understand the writer's prejudices without appreciating sources from the other side. There are few opportunities to engage in such an experience, yet on seeing first-hand the remnants of this culture and its successive dynasties we are able to greater appreciate Iran's cultural history. The exhibition "Glass, Gilding, and Grand Design: Art of Sasanian Iran (224–642)" allows us to experience that culture through a selection of nearly 75 objects drawn from European and American collections.

The Sasanian Empire, founded in the third century, wielded great influence in its time. Its territory spanned Iran, Iraq, parts of Armenia, Georgia, Afghanistan, and southern Central Asia. Some of the complexities surrounding an analysis of Sasanian art are acknowledged by the writers in this book. These include difficulties in dating material since the iconography of the Sasanians was reproduced outside the empire and long after its height, no doubt evidence of its legacy and influence. Some objects, especially silverware—a large part of this exhibition—were found in places such as China and Japan since they were traded as luxury items, as were the textiles which were brought to the West by crusaders who wrapped the relics of saints in silk. This kind of removal from an archaeological context also makes precise dating difficult. This exhibition comprises a selection of silverware, glassware, silk fabrics, weapons, and formal apparel, as well as seals and coins, and architectural settings made of stucco or mosaic. The iconography we see in these objects is evidence of a syncretism of the West, especially the Roman Empire, and the East, especially Central Asia and China. While the silverware in the exhibition shows the extraordinary luxury of court life, we also gain insight into daily life through the presentation of seals as well as pottery and glass.

Asia Society has long presented exhibitions and programs on the arts and culture of Iran. Nearly thirty years ago, Asia Society presented "The Royal Hunter: Art of the Sasanian Empire," curated by Dr. Prudence O. Harper, and more recently, "Hunt for Paradise: Court Arts of Safavid Iran, 1501–1576." The current exhibition, "Glass, Gilding, and Grand Design: Art of Sasanian Iran," brings together material from various collections to highlight the important legacy of this empire. The organization of the objects into four sections—The Arts of King and Court; Religious Traditions; Borderlands and Beyond; and The Artistic Legacy—allows us to see the culture in a new light.

This exhibition premiered at the Musée Cernuschi in Paris. It was a pleasure to collaborate with our partners in France—the City of Paris, Musée Cernuschi, and Paris Musées—on this exhibition. From the Paris Musées, I would like to extend my deep appreciation to Denis Caget, Aimée Fontaine, Laurence Jouannic, Laurence Petit, and Adeline Souverain. My profound gratitude goes to Gilles Béguin and Nicolas Engel of Musée Cernuschi for their generosity of spirit and collegiality. As curator of the exhibition,

Françoise Demange, Conservateur en chef, Département des Antiquités orientales, Musée du Louvre, provided the necessary scholarly provisions that made this exhibition possible. We appreciate that she has been the driving force behind this exhibition. The presentation in New York has been guided by the curatorial advice of Dr. Prudence O. Harper, Curator Emerita of Ancient Near Eastern Art at the Metropolitan Museum of Art, and Michael Chagnon, Research Assistant of Islamic Art at the Brooklyn Museum of Art, who has served as curatorial consultant. I would also like to express my deepest gratitude to Henri Loyrette, Président-directeur du Musée du Louvre, and Jean-Noël Jeanneney, Président de la Bibliothèque nationale de France, for their exceptional collaboration with lending objects to this exhibition. I am also especially grateful to the institutions in the United States that have lent objects from their collection for this exhibition— the Cincinnati Art Museum, Cincinnati, Ohio; The Corning Museum of Glass, Corning, New York; The Cleveland Museum of Art, Cleveland, Ohio; The Field Museum of Natural History, Chicago, Illinois; The Metropolitan Museum of Art, New York, New York; and the Arthur M. Sackler Gallery, Smithsonian Institution, Washington, D.C.—and to the individuals who have graciously lent objects from their private collections for this presentation.

This exhibition has benefited greatly from the commitment of Asia Society's staff. I want to recognize the leadership of our President, Vishakha N. Desai, and Jamie Metzl, Executive Vice President, as well as the staff of the museum: Marion Kocot, Assistant Director, who managed the exhibition team; Adriana Proser, John H. Foster Curator of Traditional Asian Art, who worked with the curator and advisors on shaping the content of the exhibition; Clare McGowan, Collections Manager and Registrar; Clayton Vogel, Installation Manager, who designed the exhibition; and Mary Chou's work on the book and interpretive materials. Also crucial to the project are Nancy Blume, Head of Museum Education Programs, who created the education programs accompanying this exhibition; Kristy Phillips and Yang Yingshi, the Museum Fellows; and Hannah Pritchard, who provided administrative assistance. Others at Asia Society who should be thanked for their support include Rachel Cooper, Director of Cultural Programs and Performing Arts; Deanna Lee and her team on public relations and marketing; Todd Galitz, Julie Lang, Emily Moqtaderi, and Alice Hunsberger for their fundraising efforts; Michael Levine and Flora Zhang for their contributions to the website production; and Peter Lukic for the design of the book.

Finally, this exhibition would not have been possible without the support of major donors. We recognize the major contributions made by The Leon Levy Foundation; The Lee and Juliet Folger Fund; Lisina and Frank Hoch; and Sheila and Hassan Nemazee. Additional support was provided by Akbar Ghahary, Ph.D.; Amita and Purnendu Chatterjee; Jamshid and Mahshid Ehsani; The Soudavar Memorial Foundation; The Beningson Family, in Memory of Renee Beningson; and The Persepolis Foundation.

Melissa Chiu
Museum Director
Asia Society

"The crown was made of gold and adorned with precious stones, dazzling with the splendor of its inset carbuncles, its frame made of a row of pearls that sparkled on the headpiece, mixing their flashing rays with the gorgeous splendor of the emeralds, so much so that the eye was almost petrified in insatiable amazement. He was wearing trousers whose fabric was interspersed with priceless hand-woven gold and, in general, his attire was as much a sign of opulence as it was proof of his taste for flaunting his riches."

Theophylactus Simocatta, IV, 3
Description of King Hormizd IV (519–590)

At the beginning of the third century, Ardashir, minor king of Persis, freed himself from the control of Artaban and, little by little, joined the territories of the Parthian Empire under his authority. He founded a new dynasty, that of the Sasanian Iranians, which, for almost four centuries, controlled the huge territory that connected the Roman and then the Byzantine world to China. An efficient administration and an official religion, Zoroastrianism, supported a centralized organization that replaced the lax structures of a feudal state. After remaining in the shadows for five centuries, this resurgence of a strong and ambitious monarchic power fostered the emergence and blossoming of a new national art.

Sasanian art is a composite and eclectic court art fed by various influences from both the West and the East. This will to bring in something new was not at the expense of the ancient Iranian-Near Eastern tradition, as seen in the gigantic cave reliefs, which perpetuated a tradition that lasted for more than a millennium. We recognize ancient Near Eastern themes at the source of many iconographic motifs, including the hunting king.

The glorious image of the sovereign lies at the core of Sasanian creations and projects the unity of the country and the authority of the crown. The king is shown seated majestically or dominating scenes of investiture, hunting, or fighting in colossal relief on the sides of mountains or in miniature on fine stone seals and at the bottoms of silver cups. Historians, such as the Byzantine Theophylactus Simocatta, described at length the luxury and the exquisite taste with which the kings surrounded themselves. They were great builders who founded new cities and built temples and palaces rich with colorful stucco settings. The sumptuous court banquets were an occasion to deploy an extraordinary magnificence that fostered an exceptional blossoming of the arts.

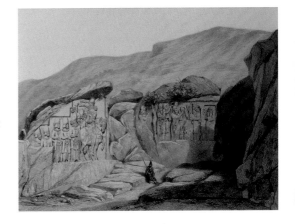

Fig. 1. Shapur I and his retinue, in the back of the investiture of Ardashir I; Naqsh-i Radjab, Iran.

Two particularities specific to the creation of Sasanian decorative art must be stressed, especially the ambiguity of the use of the term "Sasanian." We chose here to include in this term all the works that come from the same Iranian cultural tradition and use the same iconographic "language" and symbolic codes, but which were not all *produced* in Sasanian territory. Some of these objects were made in workshops located at the borders of the empire, in peripheral regions, while others were executed during the years following the fall of the Sasanian Empire, by artisans who perpetuated the old traditions.

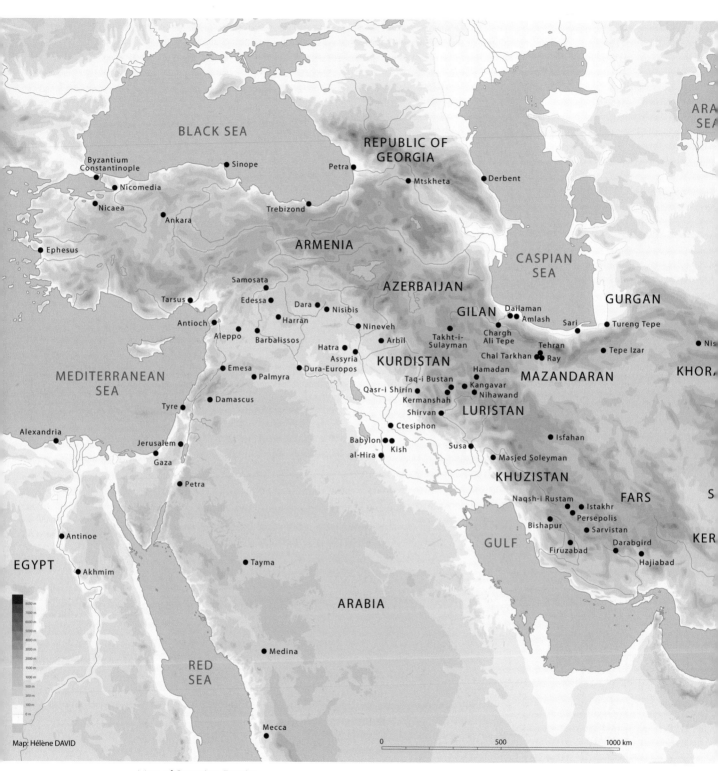

BLACK SEA

REPUBLIC OF GEORGIA

Byzantium
Constantinople
Nicomedia
Nicaea
Ankara
Sinope
Petra
Mtskheta
Derbent

Trebizond

CASPIAN SEA

ARMENIA

AZERBAIJAN

GURGAN

Ephesus

Tarsus
Samosata
Edessa
Dara
Nisibis
Harran
Nineveh
Antioch
Aleppo
Barbalissos
Assyria
Hatra
Arbîl
Dura-Europos
GILAN
Dailaman
Amlash
Sari
Tureng Tepe

Chargh
Ali Tepe
Takht-i-
Sulayman
Tehran
Tepe Izar
Nis

MEDITERRANEAN SEA
Emesa
Palmyra
KURDISTAN
Chal Tarkhan
Ray
KHOR

Hamadan
MAZANDARAN

Tyre
Damascus
Taq-i Bustan
Kangavar
Qasr-i Shirin
Nihawand
Kermanshah
LURISTAN
Shirvan

Isfahan

Alexandria
Jerusalem
Ctesiphon
Babylon
al-Hira
Kish
Susa
Masjed Soleyman
KHUZISTAN

Gaza
Petra

Naqsh-i Rustam
Istakhr
Persepolis
FARS
S
Bishapur
Sarvistan

Antinoe
GULF
Darabgird
KER
Akhmim
Firuzabad
Hajiabad

EGYPT
Tayma
ARABIA

Medina

RED SEA

Mecca

Map: Hélène DAVID

8000 m
7000 m
6000 m
5000 m
4000 m
3000 m
2000 m
1500 m
1000 m
500 m
200 m
0 m

0 500 1000 km

Map of Sasanian Empire

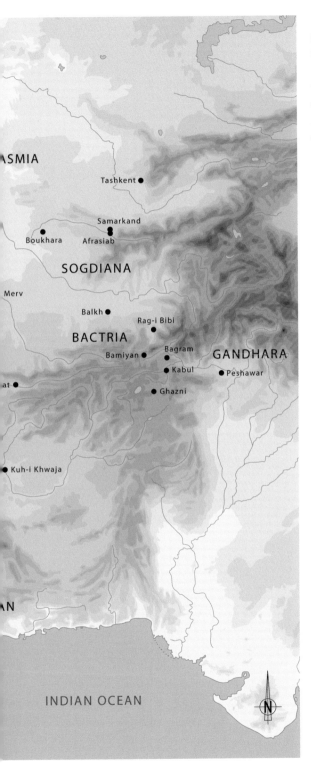

The second particularity is that, to this day, relatively few objects have been found within the borders of the empire through scientifically-conducted archaeological excavations. Luxury products such as silverware, textiles, and glassware were particularly sought after and appreciated; they were offered as gifts to the princes of allied kingdoms and to foreign ambassadors, and traded through barter or commerce. Such objects were found in places as far away as China or Japan. Numerous pieces of silverware are the product of chance discoveries from both sides of the Ural Mountains and as far north as the Siberian border. Many silk fabrics that were used to wrap relics of saints entered the West at the time of the crusades and were preserved in the treasures of churches or abbeys. But most of these works are without any archaeological context, which is why, in spite of recent discoveries, there are still many uncertainties about the exact date or precise place of manufacture of many Sasanian creations. The most striking example are the textiles, just tiny shreds of fabric that were exhumed in Iran or Iraq; while no remains of weaving workshops have been found, we know from texts that there were many active ones throughout the empire.

The approximately 75 objects presented at the Asia Society Museum in New York, thanks to the exceptional generosity of the lending institutions and individuals, constitute a selection from the exhibition of over 200 objects recently staged in Paris at the Musée Cernuschi ("Les Perses sassanides: Fastes d'un empire oublié"). The exhibition at Asia Society, "Glass, Gilding, and Grand Design: Art of Sasanian Iran (224–642)," includes precious silverware, glassware, textiles, weapons, seals, and architectural settings made of stucco and mosaic. The exhibition is organized thematically to highlight key concepts and ideas—kingship, religion, cultural exchange, and artistic legacy—that are fundamental to an understanding of the Sasanian Empire and its significance to art and history. The exhibition and accompanying catalogue, an abridged English language version of the French catalogue, provide insight into a major historic and cultural period that is still not very well known to the public, and allow for a better contextualization of contemporary discussions about Iran and Islam.

Françoise Demange
Conservateur en chef,
Département des Antiquités orientales
Musée du Louvre

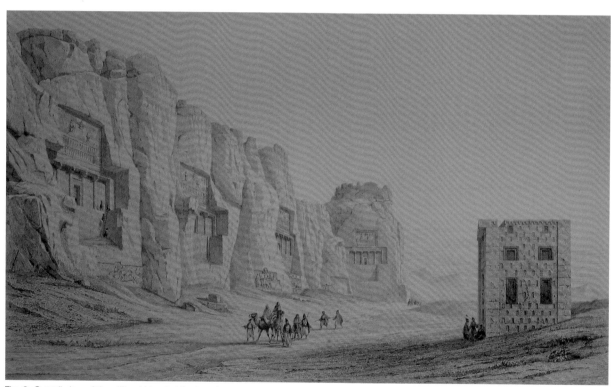

Fig. 2. Overall view of the cliffs of Naqsh-i Rustam, Iran.

THE SASANIAN WORLD
Rika Gyselen

The kinship between Sasan, the ancient eponym of the Sasanian dynasty, and the first Sasanian king, Ardashir I (reigned 224–241), remains obscure. Before ascending the throne of the empire, he was a minor king of Persis in the southern region of Iran, which was also home to the Achaemenid Iranians (circa 558–331 BCE) who left numerous monumental vestiges such as Persepolis and the cave tombs in the cliffs of Naqsh-i Rustam (figs. 2, 3). It was below these tombs that the first Sasanian kings commissioned several cave reliefs. It was also in the valley of Naqsh-i Rustam that Shapur I (reigned 241–271) commissioned his "Res Gestae" engravings, the main textual source for the emergence of Sasanian power.

The Sasanians referred to their empire by the term *eranshahr* (country [empire] of the Aryans [Iranians]). The central part of the kingdom consisted of present-day Iraq and Iran, as well as the western strip of Afghanistan and Pakistan. Following years of warfare and several peace treaties, the empire expanded to include the northern part of Mesopotamia and the Caucasian regions, including Georgia and parts of Armenia; Sasanian control of these areas generated an endemic *casus belli* with the Romans. The date of the Sasanian takeover of the western Kushan Empire (Central Asia and Bactria) is highly controversial (circa 226–368). Once this region was conquered, Sasanian power took hold very quickly with the advancement of governors and princes from the royal house to the status of Kushano-Sasanian kings. In the mid-fourth century, the Sasanians gradually lost control over this region and, after being defeated in 484 by the Hephtalite Empire, they lost power in the traditional Sasanian regions of Margiana, Arachosia, and Khorasan for some fifteen years. Allied with the Turks of Central Asia, the Sasanians succeeded in recovering the region located between the Oxus and the Sind in 560, but at the end of the sixth century, the Sasanian presence in these regions was more in name than reality. Local landowners took advantage of the situation to found autonomous principalities whose resistance considerably delayed the progress of the Arabian armies during their invasion of present-day Afghanistan. In 570, Khosrow I (reigned 531–579) secured control of the Red Sea and international trade by expelling the Ethiopians from Yemen, which became a vassal state of the Sasanian Empire. Under Khosrow II (reigned 591–628), nicknamed Abarwez (the Conqueror), the empire reached, for twenty years, its broadest extension, including the Middle East, Egypt, and Asia Minor, which was conquered from the Byzantines. This expansion phase came to an end with the invasion of the Byzantine armies that devastated Takht-i Sulayman, the national sanctuary, and the royal residence of Khosrow II in Dastagird. Between 628 and 632, half a dozen kings and queens succeeded each other on the throne. When Yazdegerd III (reigned 632–650) finally stabilized power, it was too late to save the empire, which had been significantly weakened by the numerous tactical mistakes made by Khosrow II, particularly the elimination of the Arab Lakhmid kingdom, whose principality, al-Hira, was a buffer state against the Arab tribes that had threatened the country as early as the fifth century. The conversion to Islam (622), which was intended to unify these tribes, acted as the trigger for the Arab conquest. By taking al-Hira, the Arabs paved their way to the capital, Ctesiphon. Powerless, the Sasanian army was finally defeated in Nihawand in 642. After the murder of his father Yazdegerd III in eastern Iran, and in spite of the support of the Turks and the Chinese, Peroz III (reigned 651–677) was unable to conquer back his kingdom and sought refuge at the Chinese court. The Sasanians left the Arabs with a unified empire centralized around a strong power. The Sasanian concepts of governance and royalty were taken over by the Arab-Islamic dynasties of the Umayyads and 'Abbasids.

The Arsacid Parthian Empire consisted of countless semi-independent principalities governed by local kings, some who pledged allegiance to Ardashir I, thus preserving their throne. Other regions fell under the direct control of the state, which allocated them a satrap who was often a relative of the ruling family. In his great inscription describing the empire, Shapur I did not mention the huge regions belonging to noble families such as the Waraz, the Mihran, the Souren, or the Karen, who had their own armies and constituted an unavoidable political-military force that the king had to manage. Under Kawad I, social unrest, especially that caused by the Mazdakite movement, which wanted women and wealth to be owned in common, provided sovereigns with the opportunity to change the balance of power with these traditional noblemen. It was perhaps after these troubles that the Sasanian power definitively established its control over the regions that belonged to the great families. Be that as it may, the administrative seals of the sixth and seventh centuries exhibited the provincial administrative structure applied to the entire territory at that time. After dispossessing these great families of part of their rights on their traditional lands, Khosrow I integrated them into the apparatus of the state. It was among them that he recruited the top management of the empire, especially the army command, which was no longer centralized by one supreme commander but held by four generals. Thus, these noble families forged again a power—albeit different but just as dangerous for the Sasanian dynasty—that interfered as before in the affairs of the state, especially at the time of the induction of a new king. In general, Sasanian power was transmitted from father to son, but could also go to a brother. The prerogative of crowning the new king belonged to the Suren family, at least in the first stages. Certain sources seem to indicate that this honor was later entrusted to the head of the Mazdean church. At various times, the influence of the clergy over the royalty was significant. But the main destabilizing factor for the dynasty remained the noblemen, as proven by the usurpations of Bahram Chobin (590–591), a general from the

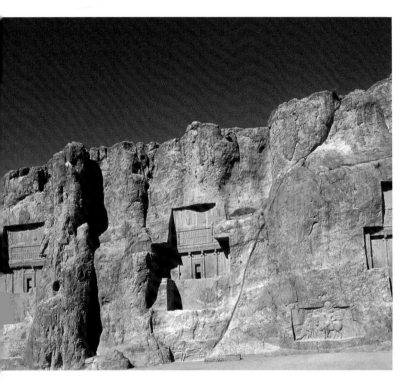

Fig. 3. Cliffs of Naqsh-i Rustam, Iran, with the Achaemenid tombs at top and Sasanian reliefs at bottom.

Mihran family, and of Wistahm (591/592–597?), maternal uncle of Khosrow II (590–628).

Ardashir I also inherited the international situation that had prevailed in the last years of the Parthian era, as well as the centuries-long enemy, the Roman Empire, which was situated at the western border of the Sasanian Empire. It was Shapur I who obtained the first brilliant victories: the death of the Roman emperor Gordian on the battlefield; the surrender of Philip the Arab; and, especially, the capture of the emperor, Valerian, with part of his army. Shapur I knew how to take advantage of the skills of the Roman prisoners of war to build great works of art, including bridges and dams. In spite of a few Sasanian setbacks, peace treaties generally ended with a tax being paid by the Romans. The incursions of the Sasanians in the regions of the eastern Roman Empire gave rise to periodic deportations, and the Sasanian kings founded numerous cities to settle these displaced populations. Thus, Shapur I built Weh-az-Andiyok-Shapur ("Shapur [did

COURT LIFE

Rika Gyselen

Fig. 4. Games and joists on a goblet (Arthur M. Sackler Gallery, Smithsonian Institution, Washington, D.C., 1987.105).

The structure of the court in the third century is known from a few royal inscriptions that contain lists of courtiers whose order probably corresponds to their rank during ceremonies. There were also very stringent rules, written in ad hoc "manuals" that have since been lost, which outlined proper etiquette for royal audiences during banquets and festivities.

Sasanian kings loved to surround themselves with minstrels and storytellers who developed secular literary genres such as courtly romances, epics, and tales. Some of these works belonged to the Parthian Iranian tradition (*Vis and Ramin*) while others were translations from Greek, Syriac, and Sanskrit. Mainly oral, this courtly literature was not put in writing until the time of Khosrow I. Only a few brief texts survived in Middle Persian; the others came to us through translations—some in Arabic, such as the Letter of Tansar on the art of government, and some in Persian, like the famous *Shahnama*, or Book of Kings, of Firdawsi.

Male and female musicians not only entertained guests during banquets but also accompanied the king in hunting expeditions. Various types of astrologists, magicians, and soothsayers were also part of the king's entourage, and their role was to advise him as to the propitious days and times for his actions.

The king and his whole household traveled often. Beyond the palace grounds, the royal domains included huge hunting preserves, "paradises" described to us by the Latin author Ammianus Marcellinus, and the cave reliefs of Taq-i Bustan. Hunting, as an allegory of war and the defeat of the enemy, was the favorite pastime of the king and his courtiers. The game of chess, which alludes to war (the pieces representing the king, the body of the elephant, the fleet, etc.) and therefore had its place in the royal ideology, was also one of the pastimes of the court.

better] than Antioch") in Khuzistan for the deportees of Antioch. Better known under the name Jund-i Shapur (or Gundishapur), this city became a famous center of "Greek" medicine and philosophy, which was attended by numerous philosophers especially after the closing of the School of Edessa (489) and that of Athens (529). At Gundishapur, Shapur founded a school of medicine significantly influenced by the theories of Galenus, and Khosrow I built a hospital called "The Academy of Hippocrates."

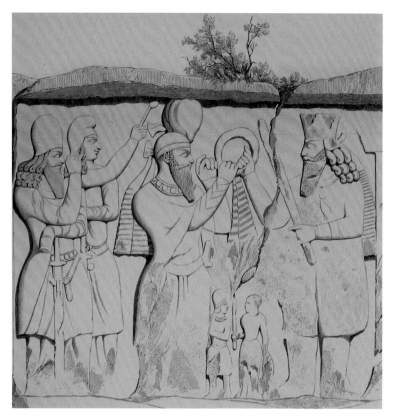

Fig. 5. Detail of the investiture of Ardashir; Naqsh-i Radjab, Iran.

In eastern Iran, a culture incorporating Iranian, Greek, and Indian elements flourished under the Kushans. Its encounter with Sasanian culture gave rise to surprising works of art, including Kushano-Sasanian coins and mural paintings. It was also in these regions—where Zoroastrianism was born probably around 1000 BCE—that a remarkable Mazdean religious art developed, which appears not to have been popular within the Sasanian Empire and whose absence in this region has been attributed to the sectarianism of the Mazdean clergy or to supposed iconoclastic movements.

Nomadic pressures along the northern borders—in the Caucasus Mountains and in northeastern Iran (Hyrcania, Margiana, Bactria) next to the steppes of Central Asia—were a constant component of the region's geopolitics. To resist this pressure, the Sasanians resumed the centuries-long tradition of building fortification networks and citadels, and erecting long walls. But by the mid-fourth century, successive waves of tribes gradually invaded the entire eastern Sasanian region and the flows did not stop until the arrival of the Turks in Central Asia in the sixth century.

Khosrow I, also named Anoshirvan (immortal soul), inaugurated an era of cultural renewal. It was during his reign, or that of his father, that a strong Indian element was exercised in the field of the arts and ideas. Literary works were translated from Sanskrit into Middle Persian—*The Thousand Tales*, *Kalila and Dimma*, or *The Book of Sindbad*—and then into Arabic, Persian, Greek, and Latin, thus reaching Europe. Also translated were numerous works of philosophy, astrology, and medicine, the latter two sciences being closely related to prophylactic beliefs and the practice of magic that was widespread throughout all classes of Sasanian society. Countless types of amulets and thousands of terracotta platters covered with invocations, often in Aramaic, show the intense use of objects that, by force of word or image, protected against illness and the evil eye.

The Sasanian period brought about significant urbanization, sustained by the kings themselves, who founded many cities that housed the deported or displaced populations whose qualified artisans made major contributions to the progress of handicrafts. The economy was based on land and agriculture, which, in most regions, required irrigation. Underground canals and bridge-dams were built—the most famous one being that of Band-e-Caesar (Caesar's dam) in Khuzistan; the name reminds us that it was built by Roman war prisoners. The most productive grain, sugar, and winegrowing regions were located in Mesopotamia, Khuzistan, and around Darabgird in Fars. The state's main sources of revenue were land taxes on harvests, personal taxes, which, in the end, applied only to the commoners, and customs duties on international commerce. Mining activity (gold, silver, copper, semi-precious stones) and the location of the mines are not well known. The production of luxury objects for the court and international trade (silver and glass vessels, brocade) may have been the monopoly of the royal workshops, often located in royal cities such as Iwan-e Karka, which was founded by Shapur II north of Susa.

The Silk Road

Rika Gyselen

The Silk Road is the generic name given by Westerners to the network of trade routes through which raw Chinese silk was sent to the West. Starting from the Chinese capital Chang'an, it split into three land routes in Dunhuang, which were connected by secondary routes. The central route (Turfan–Kucha–Kashgar–Balkh), controlled by the Sogdian merchants of Kucha, joined a branch of the northern route (Tashkent–Samarkand) at Merv and crossed Nishapur, Rayy, and Hamadan, after which it reached the capital Ctesiphon and beyond to the eastern Mediterranean. Starting from the southern route (Khotan–Kunduz), several roads led to the mouth of the Indus, where the maritime routes began. The route of the Red Sea, which bypassed the Sasanian Empire, was especially used by Egyptian and Syrian merchants of the Roman Empire, while the Persian merchants used the road of the Persian Gulf to reach southern China and the Far East.

For the Chinese, the Silk Road was referred to as the Horse Road, because it was traversed by horses bought in Central Asia, or the Glass Road, since glass was a product highly appreciated in China and manufactured in the eastern Mediterranean, Sasanian Iran, and northern India. Bronze mirrors, paper, and lacquer came from China. Gold and silver were sent to China in the form of coins, plates, and bowls. Although these objects were generally melted in China, a few still survived in reserve treasures. Sasanian Iran exported silk brocaded with gold and silver, fine pearls, and agate and rock-crystal beads, which were indispensable for goldsmiths, jewelry, and garment decoration, as well as for the famous Chinese bead curtains. The Silk Road was also an extraordinary vehicle for philosophical ideas, techniques, and religions, especially Christianity, Manicheism, and Buddhism.

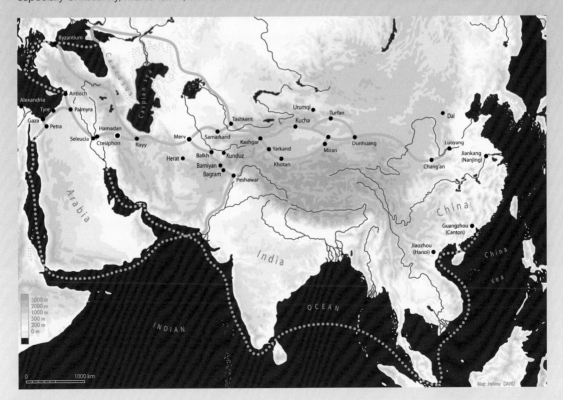

Map: Hélène DAVID

A State Religion: Zoroastrianism

Rika Gyselen

The national Mazdean church

The first Sasanian kings proclaimed themselves "Mazdean" on their coins and in their inscriptions. Under Bahram II, the Mazdean priest Kartir succeeded in installing a clergy hierarchy whose presence and structure expanded over the next three centuries. By the sixth to seventh centuries, the Mazdean church controlled the entire legal-religious organization of the state as well as the national territory through several types of administrations.

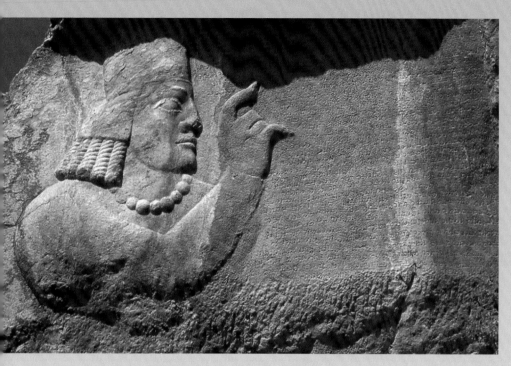

Fig. 6. The Mazdean priest Kartir; Naqsh-i Rajab, Iran.

Zoroastrianism—after the name of the prophet Zoroaster (or Zarathustra)—is a dualistic religion in which the principles of good and evil are in battle with each other. The battle was won by Ahura Mazda, "Master of Wisdom," who is the source of the term Mazdeism, which is another name for this religion. Ohrmazd, another form of the name Ahura Mazda, is surrounded by divinities that incarnate various concepts opposed to the malefic forces of Ahriman. Fire, the symbol of Ohrmazd, plays a central role in Zoroastrian ritual and is sheltered and venerated in the temples of fire. Sanctuaries have also been dedicated to the goddess Anahita and the sun god Mithra, who are both integrated in the Zoroastrian religion. To avoid the desecration of the four sacred elements—water, air, earth, and fire—numerous purification rituals are applied; for example, the funereal practice in which the corpse, considered the main cause of pollution, was left for dogs and other scavengers while the bones, considered the seat of the soul, were gathered and preserved for resurrection. Physical purity accompanied moral purity, according to the triple golden rule—good thoughts, good words, good actions.

It was only towards the end of the Sasanian period when the teachings of Zoroaster, transmitted orally for centuries, were written in Avesta, or the founding texts of Mazdeism. The doctrine, eschatology, philosophy, cosmology, and mythology of Zoroastrianism are contained in works in the Middle Persian language, which were not written until the ninth and tenth centuries.

Sasanian kings practiced an expansionist and authoritarian policy that created a significant mixture of populations with different ethnic origins, languages, and religions. Although certain groups preserved their religion and languages—many communities being bilingual—the Sasanian society constituted a melting pot that absorbed these various contributions and produced a culture with strong Iranian associations, offering a remarkable image of its own identity.

Religious minorities in the Sasanian Empire
Rika Gyselen

The Jews, who were deported to Mesopotamia after the conquest of Jerusalem in 587 BCE by the king of Babylon, constituted the most ancient religious minority in the Sasanian area. In these same regions, there were also a few Christian settlements. It was not until after the periodic and massive deportations of Syrian populations (especially in the third and sixth to seventh centuries) that Christianity spread throughout the empire, as proven by the Episcopal lists of synods and councils. In spite of occasional persecutions, the Jews and the Christians were integrated in the economic, administrative, and cultural fabric of Sasanian society, and may have been part of the entourage of the king, who sometimes chose favorites and advisors from these minorities. Along with these two monotheistic religions, numerous "heresies" with Mazdean (Zurvanism, Mazdakism, etc.) and Christian trends flourished.

In Bactria and Central Asia, monasteries and monuments witnessed the integration of Buddhism, which expanded at the time of the Kushans.

The only universal religion of Sasanian origin, Manicheism—a religious movement at the crossroads between Judaism and Christianity—was born in the third century in Mesena, within Baptist circles. Its prophet, Mani, preached a dualist doctrine with a highly syncretic character, mixing elements of Buddhism, Mazdeism, and Christianity, as well as certain ideas from Greek philosophy and ancient Mesopotamian religions. Under the pressure of the Mazdean clergy, the successors of Ohmazd I tried to eradicate Manicheism. In reaction, many Manichean disciples emigrated to the Roman Empire—we must not forget that Saint Augustine was first a Manichean—and to eastern Iran, Central Asia, and the Chinese Turkestan, where they created their own alphabet for Middle Persian and developed a specifically Manichean art.

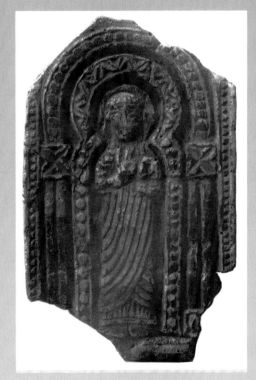

Fig. 7. Plate representing a Christian saint holding a book (stucco, H: 13.6 cm; L: 8.5 cm, discovered in Susa, Paris, Musée du Louvre, inv. Sb 9375).

THE RELIEFS OF TAQ-I BUSTAN

Françoise Demange

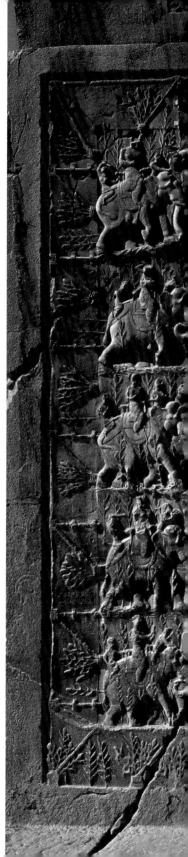

In Taq-i Bustan, not far from Kermanshah, a rock wall looms over a small lake fed by freshwater springs (fig. 10). In ancient times, this was a "paradise," a place where the king and his court enjoyed the pleasures of the hunt in a fenced-in park.

Shapur II had his coronation and his victory over Roman emperor Julian (361–363) represented in relief here; a few years later, Shapur III was an innovator in having an artificial grotto in the shape of an *iwan* carved in the rock wall: a relief shows him and his father on the back wall.

Two hundred years later a king, probably Khosrow II (591–628), resumed the tradition of rock reliefs and had a large arch carved from the rock next to Shapur's grotto. In the back, the king, wearing armor and mounted on his heavily caparisoned horse, is represented in very high relief, almost in round bosses, exactly like the figures of the coronation scene shown above (fig. 8).

On the side walls, two large panels show a deer hunt (unfinished) on the left (fig. 11) and a boar hunt on the right (fig. 9). Each tableau reads like a strip illustrating various episodes of the action, the enclosure of which forms the frame of the composition.

The boar hunt starts on the left in the marshes: elephants drive the game towards the king, in the center, who shoots at the animals. To the right, the king is represented a second time, relaxing after the hunt and listening to musicians sitting on boats that surround the royal vessel. And finally on the right, the keepers load the killed game on the elephants. The action of the deer hunt starts from the right and moves to the left, where the king is represented three times. At the top, shielded by a parasol, the king enters the park followed by his musicians. In the center, accompanied by the court, he pursues a band of fleeing deer on his galloping horse while aiming at them with his arrows. Below, he rests after the hunt. These two scenes that recount and develop the theme of the royal hunt evoke not only the symbol of the almighty and victorious king warrior but also

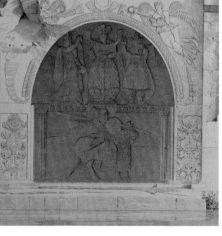

Fig. 8. Coronation of Khosrow II; Taq-i Bustan III, Iran.

Fig. 9. Boar hunt; Iran, Taq-i Bustan; right inner wall of the *iwan*; molding made from impressions taken by the French archaeological delegation in Persia in 1899; H. 4.3 m; L. 5.91 m.

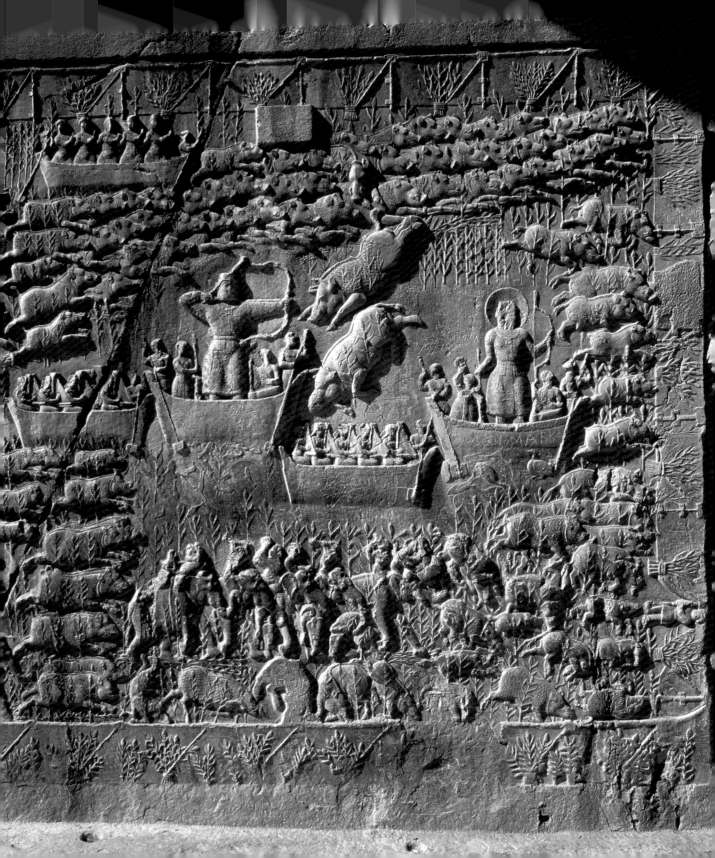

Fig. 10. View of the site; Taq-i Bustan, Iran.

sumptuous celebrations where the pomp of the court was on full view. Landscapes, animals, servants, musicians—all are detailed with a narrative élan unusual in Sasanian art. The artists who created these reliefs drew from sources that came from Byzantium, but also from the east of the empire, and even from China, as is evident in the iconography and style of the reliefs.[1]

As with the two columns sculpted with acanthus leaves that frame the entrance of the *iwan*, these panels are reminiscent—both for their subject matter and for their representation in very flat relief—of the stucco ornaments and paintings decorating the palace walls. The reliefs themselves were probably stuccoed and enhanced with lively colors.

The reliefs at Taq-i Bustan were copied in full scale and made into plaster molds in the spring of 1899 by the French delegation in Persia under very difficult circumstances. Each panel was cast in six or eight different components. They were then restored and reassembled. These castings are precious documents because the originals that were exposed to the elements have deteriorated.

1. cf. perspective.

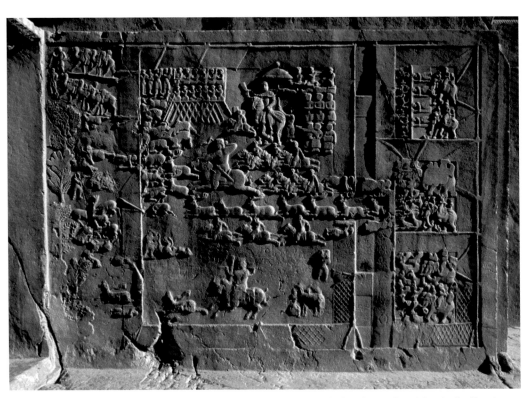

Fig. 11. Deer hunt; Iran, Taq-i Bustan; left inner wall of the *iwan*; molding made from impressions taken by the French archaeological delegation in Persia in 1899; H. 4.3 m; L. 5.87 m.

THE MOSAICS OF BISHAPUR
Françoise Demange

Shapur I most likely started building the new city of Bishapur in Fars[1] in 260, at the peak of his glory after brilliant victories over the Roman armies.

Archaeologists have identified the vast architectural complex in the northern zone of Bishapur as a palace, although it may have been a large fire temple.[2] This complex consisted of a large room in the shape of a cross, probably covered with cupolas, connected to a small semi-buried construction, which received water through an underground pipe; around the complex there were yards and rooms whose layout had been changed several times. The original grounds of two of these buildings were paved with mosaics, which were extremely fashionable in the West but unusual in Iran where people preferred to cover the tiles with carpets.

One of these mosaics was irremediably lost, but in one room (perhaps a vast *iwan*) whose walls were originally pierced with deep niches, panels of mosaic along the walls composed a broad colorful edge framing the black limestone floor. Large rectangular panels framed noble ladies, female dancers, and musicians within geometric motifs fitted into the niches and combined with narrower panels simply decorated with three or four male or female heads that resemble masks.

This is an iconographic technique and program that derived directly from Western models and more particularly from the mosaics that decorated the opulent dwellings of Antioch,[3] where exceptional mosaic workshops flourished in the third century.

The masks in the panels represent Dionysian figures such as satyrs with long pointy ears and bold, bearded fauns. Some of them are resting on a *pedum*, the shepherd's hooked stick, which is one of the characteristic attributes of these figures. There are also sketches of Greco-Roman mosaics that served as models for the female dignitaries; however, the scarcely veiled nudity of the dancers and musicians as well as the long-sleeved robes adjusted for the ladies of the court are typical of Iranian figures, which are commonly depicted on silver vessels.

Syrian artisans probably laid the mosaics; Shapur conquered Antioch twice and deported to Iran, architects, masons, and artisans who probably worked on the Bishapur site. Even though the mosaic artists brought their knowledge and their sketches, they knew how to adapt their models to create an original work designed to adorn the floor of a room reserved for ceremonies and feasts.

1. The site was partially excavated by a French archaeological mission led by Ghirshman between 1935 and 1941.

2. Dietrich Huff, "Architecture sassanide," in *Splendeur des Sassanides, l'Empire perse entre Rome et la Chine (224–642)*, 52–53 (Brussels: Musées Royaux d'Art et d'Histoire, 1993).

3. Maison du Ménandre, Maison des Mystères d'Isis, Maison du Bateau des Psychées, Villa Constantinienne; cf. Roman Ghirshman, *Bîchâpour*, vol. 2, *Les mosaïques sassanides* (Paris: Librarie orientaliste P. Geuthner, 1956); Hubertus Von Gall, "Die Mosaïken von Bishapur," *Archäologische Mitteilungen aus Iran*, new series, 4 (1971): 193–205; J. C. Balty, "Les mosaïques," in *Splendeur des Sassanides*, 67–68.

SILVER VESSELS
Prudence O. Harper

Silver vessels decorated with royal images

In recent decades as our knowledge of Sasanian culture has grown, ideas held by earlier generations of scholars concerning the identification of silver vessels made within the Sasanian Near East and the techniques used for their manufacture have changed substantially.[1] Even now there is much that is unknown or uncertain concerning the silver vessels—where and when they were made; the significance of the scenes represented on them—but it is generally agreed that a new, elite silver production began in Iran following the establishment of the Sasanian dynasty in the mid-third century and lasted until the end of the Sasanian era. Among the earliest works are examples decorated with images of members of the royal clan, the great nobility, and the highest ranks of the state bureaucracy. These persons are portrayed on silver bowls, on a silver plate, and on a cup as busts enclosed within medallions (cat. 1). Less common and perhaps reserved for members of the royal clan are open plates on which equestrian hunters are portrayed pursuing wild animals. All of these earliest Sasanian silver vessels, some of which have Middle Persian inscriptions, were found by chance in Iran and under more controlled circumstances in lands in the West: Georgia, Abkhazia, and Azerbaijan.

Both the medallion portrait and the hunt are common subjects in the decoration of contemporary Roman silver and cut glass vessels made in Syria and the Black Sea region; these prestigious works undoubtedly influenced the Sasanians in their use of similar icons to express Iranian royalty and authority. It is true that the existence of a court silver production and the theme of the hunting king have long histories in Iran going back to Achaemenid and pre-Achaemenid times, but the form and style of the early Sasanian works demonstrate a reliance on contemporary Roman models.[2]

From a study of the early vessels with images of elite persons in portrait medallions and participating in a hunt, it is evident that more than one style or workshop tradition existed. This is most noticeable in the depiction of the drapery folds, which, on some examples, are naturalistically portrayed while on other pieces are stylized in a fashion used in the preceding Parthian period as a series of close parallel lines curving over and giving some definition to the body surface beneath.

The first known representation of a Sasanian king on a silver vessel appears on a cup, a Roman shape, found at Sargveshi in Georgia (Caucasus). The image is in the form of a medallion portrait. Bahram II (276–293), recognizable because of his crown (known from rock reliefs and coins) is shown with persons who are probably family members, a subject seen on the coins of this king. Some time later, in the early fourth century, the medallion portrait theme was replaced as a royal icon and the motif of the royal hunter became the standard type on Sasanian silver plates.

By the mid-fourth century, the image of the king hunting (identifiable by his crown) had become the exclusive royal icon represented on Sasanian silver vessels, and the production of these vessels, always plates (the bowl form as well as the medallion portrait disappear from the silver corpus), was the prerogative, in Iran, of the king of kings (fig. 12, cat. 1). Lesser members of the royal family or high nobility were not portrayed again on court silver vessels until the end of the period. This standardization or control over the style and iconography of the silver vessels on which the king appears also extends to the type of metal used which, through neutron activation analysis, has been determined to come over a considerable period

of time from a single source. An art historical analysis of silver plates on which a Sasanian king, wearing a crown known from the coins, is depicted hunting wild animals provides a long list of iconographic, stylistic, and technical details that characterize the scenes on the plates. As with the earliest silver vessels, the most visually striking feature is the method of depicting the drapery. But on the royal plates of the fourth century and later, a new convention is used and the folds appear as short paired lines. Other consistent characteristics include the balanced and iconic appearance of the scene and the arrangement of the subject so that it fits entirely within the circular frame of the plate.

While this group of Sasanian royal plates is easily identified by the characteristics mentioned above as well as by many minor details, there are other vessels decorated with hunters wearing headdresses unlike any known Sasanian crown types that differ to a greater or lesser degree from the standard Sasanian court model described above. One group of such variants appears early and was probably initiated at the time of Sasanian and Kushano-Sasanian rule in the Kushan lands in Bactria, east of Iran, in the late third and early fourth centuries. The relation of this provincial, eastern production to the works made in early Sasanian Iran is evident in the stylization of the drapery folds in a fashion already seen on some early Sasanian medallion bowls. A series of parallel lines, schematized somewhat differently and more unrealistically as wavy lines, ripple across the body surface without reference to the form beneath. As with the paired-line drapery style of the Sasanian court plates, many other features are consistently associated with the plates displaying this drapery style. Particularly striking is the dynamic, triangular composition of the scene as well as the arrangement of the design so that parts of figures are cut off by the frame of the plate. Both are features that give a less contrived appearance to the scenes and relate them to hunting scenes in the art of the Hellenizing world, a world that extended, with the conquests of Alexander the Great in the fourth century BCE, into Bactria. The fact that Sasanian governors ruling in east in the former Kushan lands, at times independent of the Sasanian political center in Iran, wished to emulate the Sasanian royalty by producing prestigious silver vessels is not surprising. What is striking is how popular the hunt theme was outside of the Sasanian court centers and how the distinctive, rippling, parallel-line drapery style persisted east of Iran long after the Kushano-Sasanian period. Associated with rulers in the East, the parallel-line style is the counterpart of the paired-line style of central Sasanian Iran. The two schools of metalworking illustrate the perceived significance in the greater Iranian world of traditional forms and designs.

Fig. 12. Dish: King Hormizd II or Hormizd III hunting lions; Iran; Sasanian, 400–600; gilt silver; H. 4.6 cm; w. 20.8 cm; The Cleveland Museum of Art, John L. Severance Fund, 1962.150.

In addition to these two distinctive styles or workshop traditions there is evidence of a number of other local productions of vessels decorated with elite (but not Sasanian royal) hunting scenes. Most examples can be associated with events occurring on the eastern borders of Sasanian Iran and either reflect in composition and style new influences from the Sasanian center as lands were reconquered by Sasanian monarchs or express a more independent identity when pressures from the Sasanian center diminished.[3] A good parallel for this phenomenon is provided by the coins minted by a variety of peoples in the East, Kushano-Sasanians, Kidarites, Hephthalites, and various clan leaders whose identity is sometimes unclear. To a greater or lesser degree these coins are modeled on the royal Sasanian coins which were widely used and known.

The medallion portrait and the hunt are not the only royal icons represented on vessels attributed to Sasanian workshops. A third image, the enthronement scene, appears on two early Sasanian rock reliefs

and on late Sasanian vessels. The image of the king is always frontal. He is seated holding a sword between his bent and spread legs. On the early rock reliefs, the throne on which he sits is similar to the lion-legged bench throne of Sasanian coins, a traditional form reminiscent of much earlier Achaemenid images still visible in Sasanian times at Persepolis and Naqsh-i Rustam.

This brief survey of both Sasanian and provincial vessels with royal images provides some indication of the complexity of cultural interactions and developments in the arts of the era. Sasanian Iran and Mesopotamia were never isolated culturally from the lands on the eastern and western borders, and both a receptiveness to foreign modes and a reverence for traditional imagery were important factors in the court art of the Sasanian period, as they had been in more ancient Achaemenid times.

Luxury vessels made of silver, gold, and high-tin bronze

Sometime in the late fifth and throughout the sixth and early seventh centuries there was an expanded production of Sasanian silver vessels including new shapes decorated with a variety of plant, animal, and human figural subjects.[4] The reason for this development is probably found in the upheavals in the structure of Sasanian society brought about by the teachings of Mazdak, the leader of a sectarian movement in Iran who advocated radical social and economic reforms. Supported at first by the Sasanian king, Kavad I, in the last decade of the fifth century, the revolutionary policies of Mazdak led to changes in the established centers of power in Iran. Although Khosrow I (531–579) suppressed the revolt, the power of the great noble families (*buzurgan*) was diminished and a new lesser nobility (*dekhan*) who owed their existence and support to the king of kings was created. It seems probable that the greater number and variety of Sasanian silver vessels is a reflection of these changing social dynamics within Iran, and that by the reign of Khosrow I a broader range of persons were in a position to commission and own prestigious objects of luxury.

In this expanded silver production, as in the earlier period, a weight measurement (based on the Sasanian coin [drachm] weight)[5] and, less commonly, an owner's name, are occasionally dotted onto the exterior of the vessel beneath the rim and on or within the foot ring. The precious vessels were not only prestigious objects but also had value as a reliable medium of exchange.[6]

Whatever the historical explanation for the expansion of the corpus of Sasanian silver vessels, it is evident from the material remains that new shapes and designs were introduced in the second half of the Sasanian period. Many of the new shapes derived from continuing contacts with lands west of Iran and Mesopotamia, in Syria, Georgia, Armenia, and the eastern Mediterranean world. The Sasanian vase (cats. 6, 12), ewer (cat. 14), and high-footed bowl are modifications of late Roman forms and, in many instances, the new images are ones that were widely familiar in the Mediterranean world: scenes of vine scrolls, vintaging, and more explicitly Dionysiac imagery; figures of dancing females holding attributes similar to objects associated in Roman art with the Hours, and the Seasons and Months (cat. 6); scenes including nude, curly haired youths, modeled on Hercules, struggling with wild animals and standing with winged horses as seen on a plate in this exhibition; river or ocean landscapes that generally follow the pattern for Nilotic scenes, a theme depicted on silver vessels, textiles, mosaics, and glass in Egypt and elsewhere in the Roman Empire. Signs of cultural interaction with the West are not surprising to find as western artisans moved continuously across borders to market centers in the East, and many craftsmen were among the prisoners of war from the eastern Roman world transported to Iran and Mesopotamia and resettled within the Sasanian kingdom. These artisans must have brought with them the tools of their trade including pattern books, models, and molds.

Other influences from the Greco-Roman world on Sasanian art reached Iran both early and late in the period from the East, notably Bactria (present-day northern Afghanistan, southern Uzbekistan, southern

Tajikistan), where the conquests of Alexander the Great in the second half of the fourth century BCE had introduced Greek colonists and culture. Hellenistic subjects and styles as well as earlier Achaemenid Iranian forms and motifs persisted on the northeastern periphery of Iran as late as the fifth and sixth centuries, long after they had disappeared in the central Sasanian realm.

Less evident than a reliance on Greco-Roman forms and designs on the Sasanian silver production are influences from western Central Asia and India. At least one unusual form of lobed elliptical bowl, having individual lobes (in contrast to the common Sasanian type with some conjoined lobes), is comparable to a vessel decorated with an Indian sea monster, a *makara*, attacked by a feline.[7] This vessel, found in China, has been attributed to the fifth century and must have been made in northwestern India where both Indian and Iranian artistic influences were present and where the type could have stimulated a related production in Sasanian Iran. Similarly, the animal-head wine vessel (cat. 10) appears to have been more popular at this time in Sogd than within the Sasanian realm where even the winehorn, an age-old Near Eastern favorite, is practically unrepresented. Among finds made in Iran are hemispherical and lobed bowls having a loop attached to the rim, as seen in one example (fig. 13) in the exhibition. Such bowls, suspended from belts and harnesses, were traditionally carried by nomadic horsemen—Alans, Huns, and Avars—on Iran's northern borders, some of whom served as allies or mercenaries in the Sasanian armies late in the period.

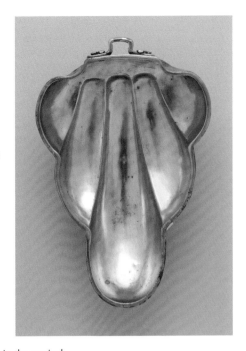

Fig. 13. Half-lobed bowl; Iran; Sasanian, 6th century; silver; H. 5.21 cm; W. 13.21 cm; D. 19.99 cm; The Metropolitan Museum of Art, Rogers Fund, 1991 (1991.73).

Questions concerning the original place of manufacture of Sasanian silver vessels are difficult to answer with certainty because of the absence of a meaningful archaeological provenance. Few examples come from controlled excavations in the Near East or western Central Asia. A much greater number are chance finds made in recent centuries in the Ural mountain region of Russia and, in the last decades, in western China, distant locations to which the precious works were carried as objects of exchange and trade.

The themes of the varied designs on late Sasanian silver vessels appear to celebrate the prosperity and fertility of this world, appropriate subjects for vessels that must have been used at festal occasions held during the Zoroastrian calendrical year.[8] The balance and order seen in the arrangement of the designs are also features that characterized Zoroastrian society and the life of the true believer. It is important to note, however, that while these concepts are consistent with Zoroastrian beliefs about the world and the cosmos, the scenes on Sasanian silver vessels do not show specific Zoroastrian religious rituals or cult activities in contrast to the art of the Greco-Roman world and many contemporary Central Asian kingdoms.

In the non-Zoroastrian community in Iran and Mesopotamia, some persons also achieved wealth and high rank. Christian bishops served as diplomats and Christians held important positions in the state bureaucracy. A few late Sasanian silver vessels decorated with a Christian cross were unquestionably commissioned by members of the Christian community and may even have had a liturgical function. Dionysiac motifs and simple vintaging scenes, pagan subjects that were adopted by early Christian artists in the Mediterranean world, may also have been used to decorate silver vessels owned by Christians living within the borders of the Sasanian kingdom. A late Sasanian hemispherical bowl found in eastern Georgia has a cross at the center of the interior but the exterior has an elaborate tree scroll and a vintaging scene of purely Sasanian style and design.[9]

The active exchange of luxury goods throughout the late antique world included not only silver vessels but also silk textiles, glass, and seals carved from precious and semi-precious stones and silver and gold coins, products that moved along extensive land and sea routes connecting eastern Europe, the Near

East, Southeast Asia, and China. In the artistic centers on these routes patterns typical of one medium were often transferred to works made in other luxury media. Some late Sasanian silver vessels illustrate motifs in which the subject is enclosed within a roundel and to those persons familiar with the court arts of the era the gilded-silver vessels must have appeared to be wrapped in a silk textile. The facetted decoration on some of the early medallion portrait bowls (cat. 1) resembles the wheel-cut designs on precious Late Antique and Sasanian cut glass vessels.

While the focus of this brief essay is the silver-gilt vessel, it is of interest to note that certain late Sasanian silver vessel shapes were reproduced in other less precious materials, notably high-tin bronze and pewter.[10] Tarnished, the bronze vessels have a beautiful black sheen or patina like tarnished silver, and the vessels, which require a special technique to manufacture, must have been prized works of art.

1. For more detailed studies of this subject see: Prudence O. Harper and Pieter Meyers, *Royal Imagery*, vol. 1, *Silver vessels of the Sasanian Period* (New York: The Metropolitan Museum of Art in association with Princeton University Press, 1981); Boris I. Marshak, *Silberschätze des Orients: Metallkunst des 3-13, Jahrhunderts und ihre Kontinuität* (Leipzig: E.A. Seemann, 1986); Kamilla V. Trever and V. G. Lukonin, *Sasanidskoe serebro: sobranie Gosudarstvennogo Ermitazha: khudozhestvennaja kul'tura Irana III-VIII vekov* (Moskva: "Iskusstvo," 1987).

2. Philippe Gignoux, "La chase dans l'Iran sassanide," *Orientalia Romana, Essays and Lectures, 5, Iranian Studies* (1983): 101–118.

3. Prudence O. Harper, "Silver-gilt Plate," in *Glories of the Past*, ed. Dietrich von Bothmer (New York: The Metropolitan Museum of Art, 1991), 58–59; Prudence O. Harper, "A Kushano-Sasanian Silver Bowl," in *Archaeologia Iranica et Orientalis*, eds. L. de Meyer and E. Haerinck, vol. 2 (Gent: Peeters Presse, 1989), 847–866.

4. Prudence O. Harper, "Sasanian Silver," in *The Seleucid, Parthian and Sasanid Periods*, vol. 3, *The Cambridge History of Iran* (Cambridge: Cambridge University Press, 1983), 1113–1129; Prudence O. Harper, "La vaisselle en metal," in *Splendeur des Sassanides, l'Empire perse entre Rome et la Chine (224-642)* (Brussels: Musées Royaux d'Art et d'Histoire, 1993), 95–108.

5. The weight of Sasanian coinage followed an Attic standard since the time of Alexander the Great.

6. Christopher J. Brunner, "Middle Persian Inscriptions on Sasanian Silverware," *The Metropolitan Journal* 9 (1974): 109–121; Michael Vickers, "Metrological Reflections: Attic, Hellenistic, Parthian and Sasanian Gold and Silver Plate," *Studia Iranica* 24 (1995): 163–184.

7. Boris I. Marshak, "Central Asian metalwork in China," in *China: Dawn of a Golden Age 200-750 A.D.*, James C. Y. Watt and others (New York: The Metropolitan Museum of Art; New Haven: Yale University Press, 2004), 151.

8. Prudence O. Harper, "Sources of Certain Female Representations in Sasanian Art," in *La Persia nel Medioevo* (Rome: Accademia Nazionale dei Lincei, 1971), 503–515; Boris I. Marshak, "The decoration of some late Sasanian silver vessels and its subject-matter," in *The Art and Archaeology of Ancient Persia: New Light on the Parthian and Sasanian Empires* (London: I. B. Tauris in association with the British Institute of Persian Studies, 1998), 84–92.

9. *National Treasures of Georgia* (London: Philip Wilson, 1999), no. 98, p. 201.

10. Assadullah S. Melikian-Chirvani, "The White Bronzes of Early Islamic Iran," *Journal of The Metropolitan Museum of Art* 9 (1974): 123–151; Prudence O. Harper, *The Royal Hunter: Art of the Sasanian Empire* (New York: Asia Society, 1978), 92–95.

SASANIAN GLASSWARE
David Whitehouse

The study of Sasanian glassware began much later than the study of other categories of Sasanian artifacts such as metalwork and architecture.[1] I will approach this problem by discussing four topics: the study of Sasanian glass; the general characteristics of Sasanian glass; the evidence of archaeological finds in the Near East; and the contribution of datable or apparently datable finds from China and Japan.

The study of Sasanian glass

The study of Sasanian glass began long after the study of coins and silver objects.[2] Glass is absent from the chapters dedicated to Sasanian art and architecture in the first volume of *A Survey of Persian Art*[3] published in 1938; it is briefly mentioned in an overview of pre-Islamic and Islamic glass and it occupies less than one page. At the time, the author, Carl Johan Lamm,[4] could cite just one major object, the famous Khosrow I plate, in which certain elements are made of glass, and a few fragments originating from three archaeological excavations in Susa,[5] Ctesiphon,[6] and Kish.[7]

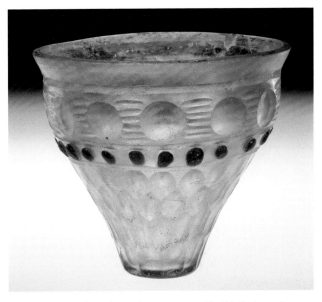

Fig. 14. Beaker or lamp; Iran (probably); Sasanian, probably 4th–7th century; transparent very pale green, with translucent blue blobs; mold-blown, applied and facet-cut; H. 9.3 cm; Collection of The Corning Museum of Glass, Corning, NY; 63.1.21.

Eighteen years later, in the exhibition catalogue *Glass from the Ancient World*,[8] Ray Winfield Smith dedicated just ten lines to Sasanian glass and only five vessels were identified with certainty as Sasanian. Yet Smith, an indefatigable collector, had a profound knowledge of ancient glass; it is clear that in 1957, a detailed knowledge of Sasanian glass still did not exist.

At the beginning of the 1960s, Parthian and Sasanian cemeteries were found in Gilan Province of northern Iran: subsequently, glass vessels appeared on the antiquities market in Tehran[9] and a sudden interest in Sasanian glassware took hold of specialists and collectors alike. Tokyo University then organized several archaeological missions to Gilan, during which Parthian and Sasanian tombs containing glass beads and vessels were excavated at Hassani-mahale near Dailaman.[10]

The new finds from Iran included cups and bowls with wheel-cut decoration that often consisted of a honeycomb motif with concave hexagonal facets. These discoveries led to a reexamination of a famous object in the Shoso-in Treasury at Nara in Japan: a facet-cut bowl believed to have been given to the shrine by Emperor Shomu in 752. Lamm[11] had dated this bowl to the eighth century, but Shinji Fukai[12] was subsequently able to demonstrate that it was of Sasanian origin, as were numerous other bowls that appeared on the market.

Soon thereafter, in 1963, Axel von Saldern published a ground-breaking article on Achaemenid and Sasanian cut glass, in which he defined the characteristics of Sasanian cold-worked objects. In a subsequent

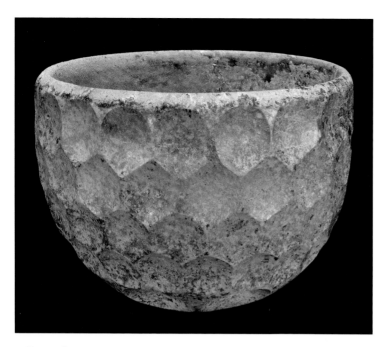

Fig. 15. Cup; Iran (possibly), Amlash; Sasanian, 5th–6th century; almost color-less with yellow tinge; blown, facet-cut; H. 8.9 cm; Collection of The Corning Museum of Glass, Corning, NY; 60.1.3.

article, he argued that some of the elaborate cut glass in the Treasury of San Marco in Venice, which is often assumed to be Byzantine, dated to the Sasanian period or the early Islamic era.[13]

This new interest in Sasanian glass is evident in the "Recent Important Acquisitions" section of the annual publication *Journal of Glass Studies*. During the decade between 1963 and 1972, thirty Sasanian or supposedly Sasanian objects were documented: this number is four times higher than the number of Sasanian glass pieces appearing in all other volumes of the *Journal* published between 1959 and 2005.

At the end of this short, formative period in the study of Sasanian glassware, the state of the question was summarized by Fukai who, in 1973, published *Perushia no Garasu* (Persian Glass), in which he reviewed the entire history of glass in Iran, giving particular emphasis to the Parthian and Sasanian periods. Fukai's monograph, published in English in 1977, includes a typology of facet-cut glass objects and numerous illustrations of Sasanian glassware.

Despite the pioneering contributions of Fukai and von Saldern, even today Sasanian glassware has scarcely entered the mainstream of glass studies. The sixteen volumes of the *Annales de l'Association Internationale pour l'histoire du verre* (Annals of the International Association for the History of Glass), which include papers delivered at the association's congresses between 1959 and 2003, contain only two contributions on Sasanian subjects[14] and the forty-seven volumes of the *Journal of Glass Studies* published between 1959 and 2005 do not have a single article on Sasanian glass.

However, during the same period, several reports on archaeological digs in Iran and Iraq provided information on glass objects, the most notable concerning the glass factory discovered in an old excavation at Tell Mahuz[15] in northern Iraq. At the same time, the results of the chemical analyses on Sasanian and supposedly Sasanian glassware published by Robert H. Brill[16] provided valuable information on the raw materials used by Sasanian glassmakers.

The characteristics of Sasanian glass

Most of the glassware known as Sasanian or believed to have been manufactured in the Sasanian Empire is transparent and either light green or more or less colorless. The greenish hue was caused by the presence of impurities (such as iron oxide) in the raw materials, while the colorless glass was obtained by adding a small quantity of manganese dioxide, intended to neutralize these impurities, in an attempt by the glassmaker to imitate the appearance of rock crystal. While they also deliberately produced colored glass (see fig. 14, decorated with drops of blue color), it seems that for high-quality cups and other vessels, the glass had to be as colorless and transparent as possible.

Sasanian glassmakers employed a variety of techniques to make their products. Blowing was the most common technique for shaping pieces. Perfected during the first century BCE in the Mediterranean Levant, this technique consisted of gathering a bubble of molten glass at the end of a hollow pipe and inflating it

by blowing into the pipe. During this process, the glassmaker centered the bubble of molten glass on the pipe by rolling it on a flat surface, then created the shape by manipulating the molten glass with jacks and other tools. As this was going on, the hot glass cooled and became stiff, which is why the glassmaker reheated the glass from time to time to restore it to a soft and workable state.

Another method consisted of blowing the glass inside a mold made of earthenware, stone, or, more commonly, metal. Most of the molds used in the Sasanian period consisted of a single cup-shaped element decorated on the inside. The glassblower used the mold to decorate the paraison—a partly formed mass of glass—after which he removed it and continued blowing it until he obtained the desired shape and size. The paraisons could be decorated with more complex molds consisting of two or more elements that defined the pattern, shape, and size of the object. Another technique of decorating the object was to stamp the molten glass, a process used to decorate many Sasanian and post-Sasanian appliqués and plaques.

Besides molding and stamping, Sasanian glassmakers decorated their vessels in two different ways: the first was to work the surface while it was still hot, or to apply drops and bands of molten glass; and the second was to work the surface after the glass had slowly cooled to ambient temperature in order to prevent it from breaking if cooled too fast. The most famous Sasanian glass pieces are the ones that were decorated when the glass was cold, by cutting, molding, and polishing the glass. The artisans probably used the tools and techniques of lapidaries: rotating wheels made of metal or stone loaded with an abrasive (emery or corundum, for example, in a liquid medium); they may also have used hand-held tools such as files. Working with this simple tool kit, Sasanian artisans produced vessels decorated with finely cut concave facets that often produced a honeycomb effect or with a combination of facets and engraved linear tracings or bosses in high relief (cat. 11).

Archaeological discoveries

In the Near East

Most Sasanian glass that appears in the market is said to have been found in Iran, while most of the published material from controlled excavations was found in Iraq. This disparity means that our knowledge of the distribution of specific types of Sasanian glass, which depends on reliably reported find-places, is seriously flawed. Nevertheless, it seems useful to review what we know about where certain varieties of Sasanian glass have been found.[17]

Pieces comparable to those made of cut glass in this catalogue were found on archaeological sites in both Iran and Iraq. Fragments of tubes were discovered in Nineveh and in Tell Baruda in Iraq, as well as in Qasr-i Abu Nasr in Iran. A cup fragment similar to cat. 11 was found in Qasr-i Abu Nasr and hemispherical cups fully decorated with concave facets were found in at least seven sites in Iraq (Nineveh, Ctesiphon, Choche, Tell Baruda, Kish, Babylon, and Uruk) and in numerous sites in northern Iran (Tureng Tepe, Shahr-i Qumis, and certain sites in Gilan Province). These cups have a pattern of distribution that extends beyond the borders of Iran and Iraq, in Central Asia.

Objects decorated while the glass was hot were discovered in Choche and Uruk in Iraq, ed-Dur in the United Arab Emirates, and Gilan Province in Iran, while bowls decorated with prunts were found in Tell Mahuz in Iraq, ed-Dur, and Gilan Province.

In China and Japan

At least two pieces in this exhibition are comparable to datable works in China and Japan. A cup or fragments of cups similar to cat. 11 were found in the tomb of Li Xian, who died in 569, and his wife, Wu Hui, who died in 547 in Guyuan, in the autonomous region of Ningxia; fragments were found in a sixth- to seventh-

century archaeological context in Munakata on the Japanese island of Okinoshima. Cups similar to fig. 15 were found in China in the tomb of Liu Zong, who died in 439 at Chuncheng, Jurong, in Jiangsu Province, China and in the grave of Emperor Ankan, who died in 535 in Osaka Prefecture, Japan. Another cup of this type appears in the Shoso-in Treasury at Nara, Japan.

1. Compare the conclusions about the same construction in Oscar Reuther, "Sasanian Architecture: A History," in *A Survey of Persian Art from Prehistoric Times to the Present*, ed. A. U. Pope, vol. I (London and New York: Oxford University Press, 1938–1939), 493; and in Lionel Bier, *Sarvistan: A Study in Early Iranian Architecture* (University Park, Pennsylvania: Published for the College Art Association of America by Pennsylvania State University Press, 1986), 48–53.

2. Louis Vanden Berghe, "Historique de la découverte et de la recherché," in *Splendeur des Sassanides, l'Empire perse entre Rome et la Chine (224-642)* (Brussels: Musées Royaux d'Art et d'Histoire, 1993), 13–18.

3. Pope, *A Survey of Persian Art*, vol. I.

4. Carl Johan Lamm, "Glass and Hard Stone Vessels," in *A Survey of Persian Art from Prehistoric Times to the Present*, ed. A. U. Pope, vol. III (London and New York: Oxford University Press, 1939), 2595.

5. Carl Johan Lamm, "Les verres trouvés à Suse," *Syria* 12 (1931): 358–367.

6. O. Puttrich-Reignard, *Die Glasfunde von Ktesiphon*, Kiel, 1934.

7. S. Langdon and D. B. Harden, "Excavations at Kish and Barghutiat 1933," *Iraq* 1 (1934): 113–136.

8. *Glass from the Ancient World, The Ray Winfield Smith Collection* (Corning: The Corning Museum of Glass, 1957), 189–225.

9. Shinji Fukai, *Perushia no Garasu* (Kyoto, 1973); Shinji Fukai, *Persian Glass*, trans. Edna B. Crawford (New York: Weatherhill/Tankosha, 1977), 23.

10. Toshino Sono and Shinji Fukai, *Dailaman III: The Excavations at Hassani Mahale and Ghalekuti, 1964* (Tokyo: Institute of Oriental Culture, University of Tokyo, 1968).

11. Carl Johan Lamm, Mittelalterliche *Gläser und Steinschnittarbeiten aus dem Nahen Osten*, 2 vols., Forschungen zur Islamischen Kunst, vol. 5 (Berlin: Verlag Dietrich Reimer/Ernst Vohsen, 1929–1930), see vol. 1, p. 149, no. 5 and vol. 2, pl. 53.5.

12. Shinji Fukai, "A Persian Treasure in the Shosoin Repository," *Japan Quarterly* 7, no. 2 (1960): 169–176.

13. Axel von Saldern, "The So-Called Byzantine Glass in the Treasury of San Marco," in *Annales du 4ᵉ Congrès des Journées Internationales du Verre* (Ravenna and Venice; Liège, 1967), 124–132. The origin of these objects is still debated and the author of this article is not convinced of their Sasanian origin.

14. An extensive one by Carol Meyer, "Sasanian and Islamic Glass from Nippur, Iraq," in *Annales du 13ᵉ Congrès de l'Association Internationale pour l'Histoire du Verre* (Pays Bas, 1995; Lochem, 1996), 247–255, and a very short one by Jennifer Price and Sally Worrell, "Roman, Sasanian, and Islamic Glass from Kush, Ras al-Khaimah, United Arab Emirates: A Preliminary Survey," *Annales du 15ᵉ Congrès de l'Association Internationale pour l'Histoire du Verre* (New York and Corning, 2001; Nottingham, 2003), 153–157.

15. M. Negro Ponzi, "Sasanian Glassware from Tell Mahuz (North Mesopotamia)," *Mesopotamia* 3–4 (1968–1969): 293–384.

16. R. H. Brill, "Chemical Analyses of Some Sasanian Glasses from Iraq," in *Sasanian and Post-Sasanian Glass in The Corning Museum of Glass*, David Whitehouse, 65–88 (Corning, NY: The Corning Museum of Glass in association with Hudson Hills Press, 2005).

17. David Whitehouse, Sasanian and Post-Sasanian Glass in The Corning Museum of Glass (Corning , NY : The Corning Museum of Glass in association with Hudson Hills Press, 2005).

Michael Chagnon

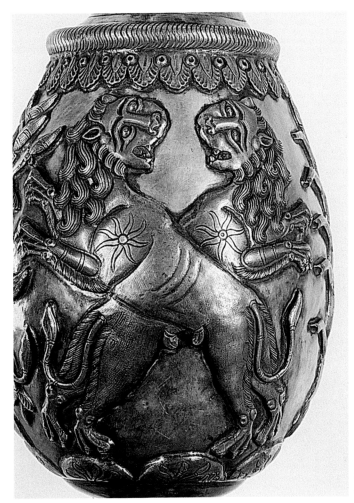

Fig. 16. Detail of lions on ewer (see cat. 14, p. 46).

The end of Sasanian rule over Iran was marked by war with the Byzantines and loss of territory in Syria and Mesopotamia, political instability, and internecine strife. After the assassination of Khosrow II in 628, as many as ten claimants to the throne vied for power, with Yazdegerd III, Khosrow's grandson, emerging as victor. Nonetheless, the erosion of Sasanian power was permanent, leaving Iran susceptible to further incursions.

Simultaneously, on the west coast of the Arabian Peninsula (the Hijaz), a new faith emerged. Called *Islam*, meaning submission (to God), this monotheistic religion was revealed by the prophet Muhammad, who politically and religiously united much of the peninsula under the banner of Islam by the time of his death in 632. Followers of the faith, *Muslim*s, formed not only a new religious community, but also a socio-political body which spread rapidly over large portions of the Middle East, Central Asia, and North Africa.

Under the Prophet's successor, Abu Bakr (died 634), Muslim armies made their first forays into Sasanian territories in Mesopotamia and Iran; in 636 during the reign of the subsequent caliph, 'Umar ibn al-Khattab, a Muslim force defeated their Sasanian foes at Qadisiyyah (near present-day Hilla in Iraq). This was followed in 641 by another at Nihawand. Yazdegerd subsequently fled east to Merv, where he was captured and killed in 651. By 674, the Muslims had extended their control over Khorasan province in northeastern Iran, and over large areas of Central and South Asia.[1]

As a primarily religious and political movement, Islam did not have an artistic tradition of its own.[2] Scholars have traditionally claimed two major sources for the formation of Islamic art: the Late Antique heritage of the Mediterranean basin and the Sasanian tradition of Iran.[3] Given the centuries of interaction between the two, it is often difficult to cite one or the other as the source for any particular monument or object from the early Islamic period.

The heart of the Islamic polity rested in various centers of its western territories up to the eighth century; however the eastern provinces, including Iran, were not arabized as quickly and native traditions and industries (e.g., glassmaking and weaving) carried on uninterrupted for a longer period of time.[4] As a result, it is difficult to ascribe closely related examples in any medium to either the Sasanian or Islamic periods with certainty. Furthermore, ancient Iranian symbols, such as the solar lion, were adapted by craftsmen working under Muslim patrons, and although they were used in the context of a new social and religious order, they never fully lost their traditional meanings (fig. 16).

Sasanian artistic vocabulary arrived in the main centers of caliphal power with the importation of Iranian craftsmen. At Umayyad palaces such as Khirbat al-Mafjar in Palestine, for example, a unique synthesis of Sasanian and Greco-Roman forms, motifs, and techniques is evident.[5]

In other cultural arenas, the Sasanians continued to play a role. Court protocol and imperial administration under the Umayyad and 'Abbasid caliphs were modeled on Sasanian precedents. In the literary sphere, a tenth- and eleventh-century revival of native Persian literature culminated in the compilation of Iranian folk tales, in the form of the *Shahnama* (Book of Kings), composed by the poet Ferdowsi of Tus around 1010.[6] The *Shahnama*, now considered the Iranian national epic, is divided into three main sections, with the last third devoted to the deeds of the Sasanian monarchs. By the fourteenth century, Ferdowsi's *Shahnama* reached unparalleled popularity, having become the main vehicle for Islamic illustrated manuscript production until the nineteenth century.

1. Fred McGraw Donner, *The Early Islamic Conquests* (Princeton: Princeton University Press, 1981).

2. A distinction must be made here between Islamic and Arab civilizations. The pre-Islamic artistic traditions of the Arabian Peninsula and other areas dominated by Arab cultures (i.e., the Yemenites, Nabateans, Palmyrenes, Lakhmids, and Ghassanids) were no doubt lively, however an overall dearth of archaeological evidence has hampered our current understanding of these traditions and their impact. See Richard Ettinghausen, Oleg Grabar, and Marilyn Jenkins-Madina, *Islamic Art and Architecture, 650-1250* (New Haven: Yale University Press, 2001), 4–6; and Annie Caubet, *Aux Sources du Monde Arabe: L'Arabie avant l'Islam. Collections du Museé du Louvre* (Paris: Institut du Monde Arabe, 1990).

3. Richard Ettinghausen, *From Byzantium to Sasanian Iran and the Islamic World* (Leiden: Brill, 1972).

4. Ettinghausen, Grabar, and Jenkins-Madina, *Islamic Art and Architecture*, esp. 293–294.

5. Ettinghausen, *From Byzantium to Sasanian Iran*, 17.

6. Abu'l Qasem Ferdowsi, *The Shahnameh (The Book of Kings)*, ed. Djalal Khaleghi-Motlagh, 6 vols. (Costa Mesa: Mazda, 1997–2005). See also Abolqasem Ferdowsi, *Shahnameh: The Persian Book of Kings*, trans. Dick Davis (New York: Viking, 2006).

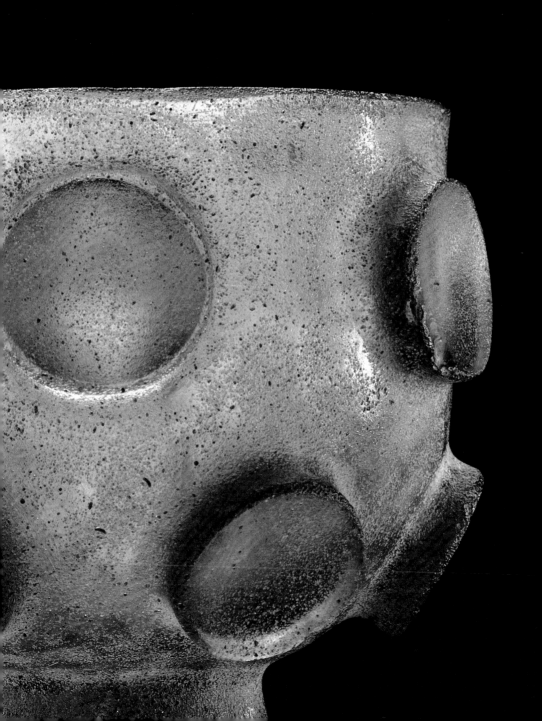

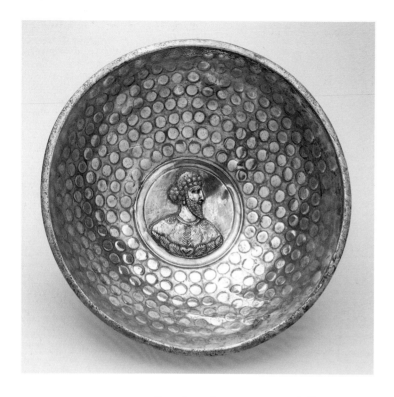

necklace and earrings, and the circular patches on the shoulders of his garment. No other attributes define his rank or position. The leaf base and the drapery are depicted in an abstract linear fashion but the modeling of the chest gives definition to the body beneath the drapery.

The circular discs decorating the sides of the bowl appear on an early Sasanian silver plate excavated at Mtskheta in Georgia and on late Roman and Sasanian glass vessels. The exterior of the bowl is undecorated but a compass point is visible at the center of the base and is surrounded by two concentric circles.

P. O. H.

1. Bowl with portrait medallion

late 3rd–early 4th century
Silver and gilt
H. 7.6 cm; Diam. 23.7 cm
Cincinnati Art Museum, Gift of Mr. and Mrs.
 Warner L. Atkins, 1955.71

The earliest Sasanian representations of members of the high nobility and the Sasanian royal family on silver vessels are in the form of a bust resting on a leaf base, enclosed within a medallion. This motif is derived from Roman models but the rather decorative treatment of the figural and plant designs on this bowl is typically Sasanian.

The bowl is one of four allegedly found together in Iran; the others are in museums in Tehran, New York, and Washington D.C. The elite status of the figure represented on the bowl in the Cincinnati Art Museum is indicated by the jewelry he wears,

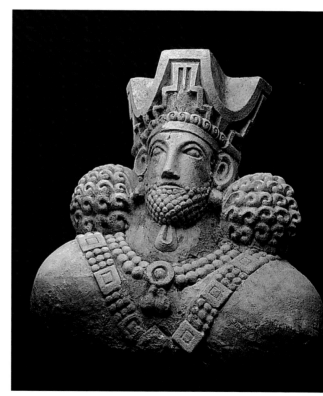

2. Bust of a king—Palace II of Kish

5th century

Stucco

H. 51.5 cm

Field Museum of Natural History, 236400a

Fourteen kings' busts of this type were found in the courtyard of Palace II in Kish. The busts were probably attached to the fourteen engaged columns that decorated the walls of the palace. This sovereign, whose bearded face is framed by two locks of curls, wears a notched crown, which must have been topped by a crescent, traces of which are still visible. At first identified as the crown of Shapur II (reigned 309–379), it also closely resembles the one worn by Bahram V (reigned 420–438). Therefore these busts are not portraits of a specific king but a more general representation of royalty during the Sasanian period.

F. D.

3. Plate: the King Yazdegerd I, slaying a stag

Iran

Sasanian, Yazdegerd I, early 5th century

Silver, mercury gilding

Diam. 23.3–4 cm; Wt. 713 g

The Metropolitan Museum of Art, Harris Brisbane Dick Fund, 1970 (1970.6)

The royal hunter is depicted standing and spearing a fallow deer; the composition is balanced and all the details of the scene fit within the circumference of the plate. On the exterior below the rim is a line or non-decorative tool mark circumscribing the vessel. The piece is inscribed on the reverse on the foot with a name and weight too worn to be deciphered.

The crown worn by the hunter is identical to the crown on the coins of Yazdegerd I with the exception of the striated globe, a detail seen on some early Sasanian works of art and on fourth-century, Kushano-Sasanian coins.[1] The spear held

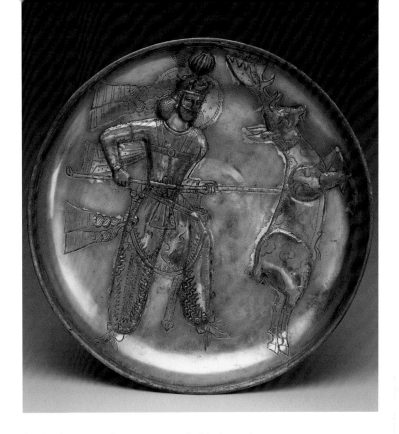

by the hunter ends in a crescentic blade, and a counterweight in the form of a closed fist appears at the opposite end of the shaft. This spurred or winged spear appears also in hunting scenes in Roman art. The stag is presumably dead or dying as the animal's tongue protrudes from its mouth falling at a right angle to its head. Details of the design and the gilding, applied over the entire designed surface except the face and hands, are typical characteristics of central Sasanian royal plates in the paired-line drapery style. Separate pieces of metal are somewhat awkwardly inserted to form the higher relief parts of the design but the work is otherwise well-executed.

P. O. H.

1. Prudence O. Harper, "Portrait of a king," *The Metropolitan Museum of Art Bulletin*, new series, 25, no. 3 (November 1966): 136–146.

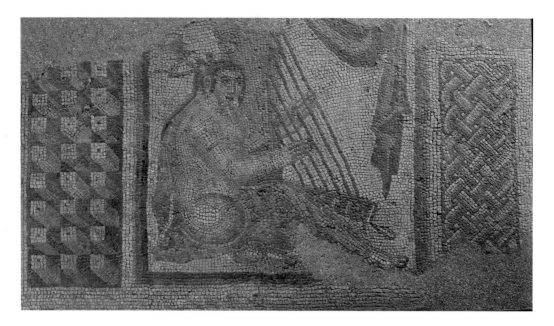

4. Mosaic plaque: Harpist

Iran, Bishapur

about 260

Marble

H. 117 cm; W. 85 cm

Paris, musée du Louvre, département des
 Antiquités orientales, inv. AO 26169

This large mosaic decorated the floor of one of the niches complementing the mosaic walls of the *iwan* at Bishapur. The geometric motifs framing the scene, depicted in perspective, are similar to the motifs on mosaics in Antioch at the same period; however, the image of the musician dressed in a light veil accentuating rather than hiding her nudity, does not belong to the repertory of Greco-Roman mosaic artists. Seated in oriental fashion, with one leg folded below the other, she is bedecked with jewelry: gold bracelets encircle her calves, wrists, and forearms; she wears pearl earrings and a necklace; and her long braids are retained by a typical Sasanian ribbon. The awkward shape of her naked body may be attributed to the artist's hesitation with depicting a new motif not commonly illustrated.

F. D.

5. Tapestry Fabric

Egypt, Antinoë (excavations by A. Gayet)

560–655 (carbon-dated)

Wool and flax (tapestry)

Largest fragment 1.00 x .82 m (mounted 1.10 x 2.00 m)

Paris, musée du Louvre, département des Antiquités
 égyptiennes, inv. E 29392 and Lyon, musée des Tissus,
 inv. 908.I.118, 119 (28.929/118, 119) kept at the Louvre

Various fragments of this tapestry from the Musée des Tissus, Lyon in the custody of the Musée du Louvre, Paris have been assembled into a hypothetical whole even though major pieces are missing and the original piece was possibly larger. The small sides have a selvedge, which forms the edge of the fabric. The wide green border is filled with stylized bouquets and the panel with a red background shows a repeated motif in a staggered arrangement in fives (quincunx), close together. The fine threads and weft made it possible to show numerous details. The mask topped by bird pairs and the double protome of griffins placed on a podium create a fantastic décor and recall the Sasanian repertoire. The direction of the script suggests that the tapestry should be hung in a vertical position, against a wall for example. A short inscription (in Greek?) is sketched in ink on the border in the upper left hand corner. D. B.

RELIGIOUS TRADITIONS

6. Vase decorated with dancers

Iran (Dailaman, Reshy?)
5th–6th century
Gilded silver
H. 18 cm
Paris, musée du Louvre, département des
 Antiquités orientales, inv. MAO426

This vase with its straight narrow neck enhanced by a pearl-like string and its pear-shaped body is decorated with female figures. It belongs to a category of vessels most typical of precious tableware from the latter half of the Sasanian era.

Four young women are depicted on the vase. They are dressed in a sleeved tunic made of transparent and embroidered muslin, which reveals their nudity; their legs are draped in pleated fabric, the ends of which are held by bent arms that suggest a dance movement with the billowing of veils. Each

dancer holds two attributes: one carries a bird, probably a pheasant, and a mythical plant; her neighbor gives a small animal resembling a panther something to drink; the third dancer holds a mirror and a vine branch with a pecking pheasant; and, a small-winged creature offers a bird to the fourth dancer who holds a ring and a cup.

The meaning of this type of design has been the subject of numerous hypotheses: Were these dancers, some of whose attributes evoke the Dionysian universe, priestesses celebrating the cult of Anahita, goddess of fertility, who had assimilated the powers of the god Dionysus, or are they simply participating in a non-religious ceremony? Although the four women have been considered personifications of the months and the seasons that existed in the Greco-Roman world, they are most likely allegorical figures representing different aspects of happiness and prosperity. Vases decorated

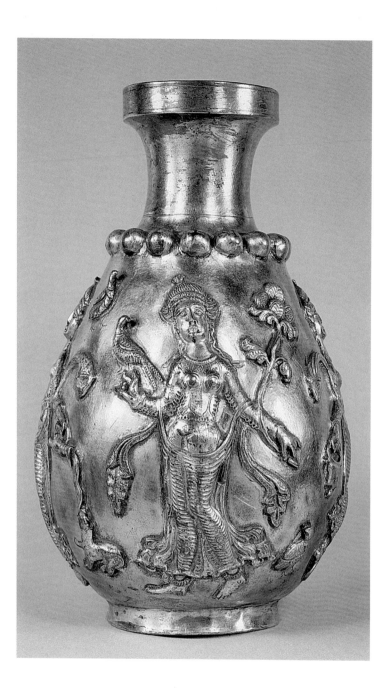

like this were used to contain wine, which was drunk at feasts, including ceremonies marking the change of seasons and in particular the important celebration of *nawruz*, the New Year.

F. D.

7. So-called "Anahita" Plate

Unknown origin/former Soltikov collection
 according to the entry register
7th–8th century
Silver, gilded background and reliefs
D. 25.8 cm; Wt. 1,212 g
Paris, Bibliothèque nationale de France, département
 des Monnaies, médailles et antiques, inv. 56.366

The center shows a naked woman bedecked with jewelry leaning on a mythological animal she clasps with her left arm. She is surrounded by figures, dressed in long robes with flowing sashes and different hairstyles, who are grouped in pairs and bear offerings. The plate is called the "Anahita" plate because it was thought, at one point, to represent Anahita (Nahid), the goddess of fertility. Numerous details, such as the hairpins, jewelry, and embroidery on the dresses are rendered by small circles, either simply cut or formed by round hollow points surrounded by an engraved circle, while the folds of the robes and sashes are represented by long cuts.

In the background, overlapping the bas-reliefs, and on the back, coarse and clumsy figures—with large heads or only heads, sometimes wearing a small bonnet or a pointed helmet—were point-engraved later. Similar graffiti was also found on silverware in Russia in the Perm region.

M. A.-B

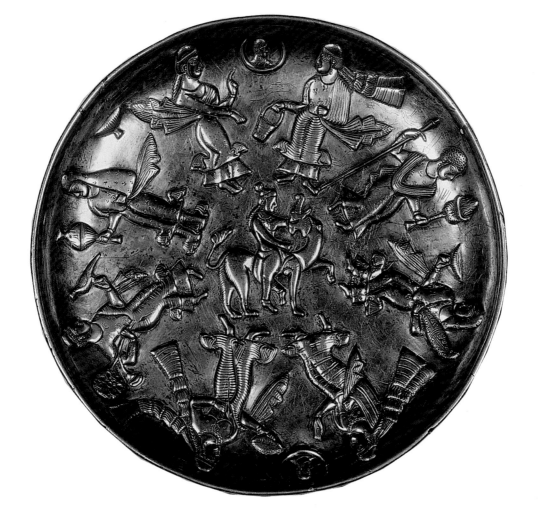

8. Stamp seal with Zoroastrian priest

Elliptical, mottled brown and white agate stone

H. 1.43 cm; W. 1.79 cm; D. 1.24 cm

Paris, Bibliothèque nationale de France, département des
Monnaies, médailles et antiques, inv. D 3404 (1854)

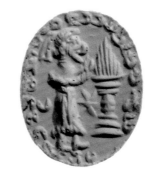

A man is depicted in right profile before a sacrificial altar on this impression of a seal. So as not to taint the altar, he wears a *padâm*, a veil covering the nose, mouth, and hair. A crescent moon and a six-pointed star are seen in the background. The Middle Persian inscription is an *andarz* (a wise saying): "That [which comes] from honesty [is] good for the gods."

R. G.

41

Borderlands and Beyond

9. Bowl

Sasanian, 3rd–4th century
Silver
H. 5.4 cm; Diam. at rim 11.3 cm
Private collection

Unusual in shape and design, this small vessel is decorated with three animal combat scenes executed in sequence: a lion attacking a bull; a lion attacking a caprid or goat antelope; and a lion attacking a stag. Two three-leaved trees and a few simple lobed mountain patterns provide a minimal landscape setting. An abstract pattern decorates the rim and the base of the bowl and resembles a curvilinear rope or vine that appears to be drawn together or "bound" at regular intervals by a horizontal element. The design is too schematic to interpret or to relate to familiar Hellenistic or Iranian border patterns. The motif of the animal combat is seen on Roman as well as Near Eastern silver vessels but the iconic and stylized forms, the minimal use of landscape designs, and the subject matter of the scenes on this bowl are comparable to works made in the steppe lands north and east of Iran. Designs on phalerae (ornaments usually adorning breastplates) of Parthian, Saka, and Sarmatian date display single animal combats including lions, rams, and stags.[1] Invariably they lack landscape elements. The meaning of those emblematic designs, made around the turn of the millennium, is uncertain but the popularity of the animal combat theme in the steppe regions from Siberia to the Black Sea from the first millennium BCE into the first centuries CE is documented by numerous works of art in different media.

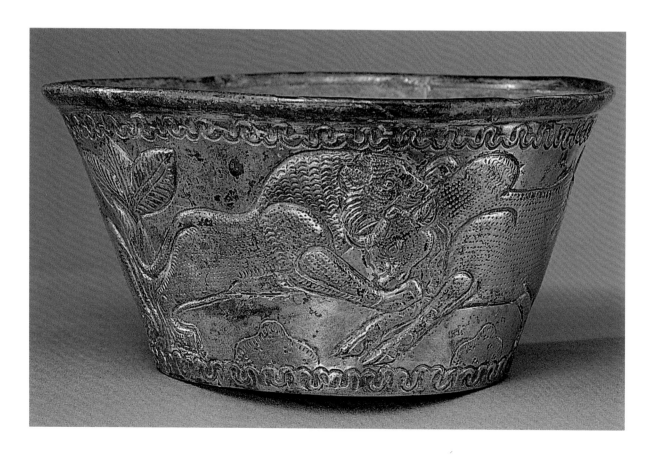

The spot gilding of the designs on this bowl is characteristic of works of Sasanian date made in eastern Iran, and it is probable that this vessel was produced by workshops located to the east and north of Sasanian centers in Mesopotamia and Iran.

P. O. H.

1. Michael Pfrommer, *Metalwork from the Hellenized East: Catalogue of the collections, the J. Paul Getty Museum* (Malibu: The Museum, 1993), 5–13, nos. 30–33.

10. Wine vessel in the form of a saiga antelope head

Found in Poland, Volhynia Choniakow

provincial Sasanian, 5th–6th century

Silver-gilt

L. of head 18.01 cm

The Metropolitan Museum of Art, Rogers Fund, 1947
(47.100.82)

Vessels in the shape of an animal head appear occasionally in banqueting scenes represented in Sasanian art. However, they are much more common in this period in the art of Sogd, in western Central Asia, where there are examples in painted scenes of celebrations and banquets in houses excavated at Panjikent (Sogd). This gilded, silver vessel, one of a pair (the other is in The State Hermitage Museum, St. Petersburg), was part of a small group of silver vessels of provincial Sasanian type found in eastern Europe in 1815 (or 1823). The ears are missing on both heads. The saiga antelope (*Saiga tatarica*) head in The Metropolitan Museum of Art is not typically Sasanian in style. It is fully but somewhat naively modeled if compared to more sophisticated works such as the antelope head in the Miho Museum, Japan.[1] This latter piece has a Middle Persian inscription, and the back plate has a typical Sasanian rosette with four heart-shaped petals. The eyes and nose of the Miho antelope are unrealistically stylized in a fashion somewhat reminiscent of animals on Sogdian silver vessels of the eighth century so the Miho piece may, in fact, have been made in an eastern Iranian workshop rather than in western Iran or Mesopotamia.

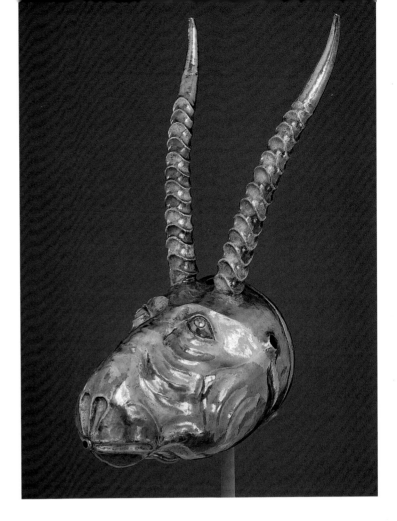

It is difficult to attribute the partially-gilded, Metropolitan Museum saiga head to a particular culture but comparisons with both Sogdian and Sasanian works of art and the rather hesitant, inexpert rendering of the antelope head suggests that it was made outside the major urban centers of Iran and central Asia perhaps in border territories occupied by the Hephthalites, Turks, and Avars.

P. O. H.

1. Ida Ely Rubin, ed., *The Guennol Collection* (New York: The Metropolitan Museum of Art, 1975), 107–112.

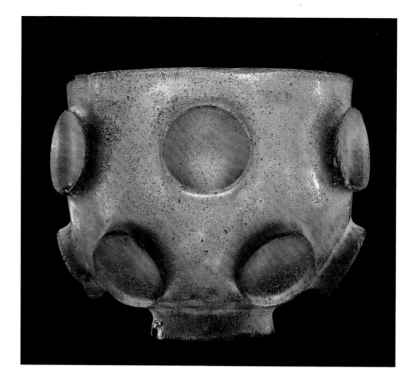

11. Cup

Iran

Sasanian, probably 6th century

Transparent light purplish brown

H. 7.2 cm

Collection of The Corning Museum of Glass, Corning, NY;
72.1.21

This hemispherical cup was probably cast but possibly blown. It was then cut and polished. The flat rim has a rounded and slightly everted lip. The wall curves down and inward; the foot is a solid cylinder. The wall is decorated with two continuous horizontal rows of six cylindrical bosses with concave surfaces. The object is not damaged except for a few chips on the rim, on some bosses, and on the foot; it is extensively pitted, with brownish weathering in the pits.

A fragment of this type of bowl was discovered during excavations in Qasr-i Abu Nasr, in southern Iran,[1] and similar pieces were discovered in the Far East. One of these was dug up in China in the tomb of Li Xian (died in 569) and his wife Wu Hui (died in 547) in Guyuan, in the autonomous region of Ningxia;[2] another was found in Barchuk in Xinjiang,[3] and fragments of a third bowl were found in the Munakata sanctuary, on the Japanese island of Okinoshima, in an archaeological context dating back to the sixth and seventh centuries.[4]

D. W.

1. Donald S. Whitcomb, *Before the Roses and the Nightingales: Excavations at Qasr-i Abu Nasr, Old Shiraz* (New York: The Metropolitan Museum of Art, 1985), 156, fig. 58k.

2. Jiayao An, "A Glass Bowl Found in the Tomb of Li Xian of the Northern Zhou Period – The Discovery of and Research on Sasanian Glassware," *Kaogu* (1986), 2:173–181; James C. Y. Watt and others, *China: dawn of a golden age, 200–750 AD* (New York: The Metropolitan Museum of Art; New Haven: Yale University Press, 2004), 61 and 258, no. 158.

3. Ellen Johnston Laing, "A Report on Western Asian Glassware in the Far East," *Bulletin of the Asia Institute*, new series, 5 (1991): 111 and fig. 8.

4. Shinji Fukai, *Persian Glass*, trans. Edna B. Crawford (New York: Weatherhill Tankosha, 1977), 44–45; Laing, "A Report on Western Asian Glassware," 118 and fig. 29.

12. Vessel

Iran
8th century
Silver, silver-gilt
H. 18.3 cm; Gr. d. 11 cm
The Metropolitan Museum of Art, Pfeiffer Fund, 1969
(69.224)

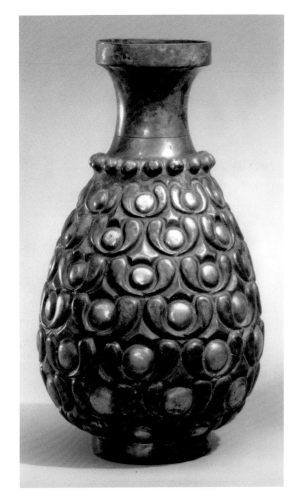

The shape of this vessel is close to the typical Sasanian vase as represented by a couple of other pieces in this exhibition. However, there are minor variations in the form: a narrower neck and more pronounced, pear-shaped profile of the body. The significance of the stylized pattern on the body, compared by some to the wings and globe of Sasanian crowns, is unclear but a similar taste for abstract designs, seemingly based on natural forms, is evident on an early Islamic bronze ewer in The Metropolitan Museum of Art (acc. no. 47.100.90) and on ceramics and architectural stucco decoration of early Islamic date.

P. O. H.

13. Molding from arched doorway, with palmettes

Mesopotamia, Ctesiphon, Umm ez-Za'tir
Sasanian, 6th century
Stucco
H. 39.4 cm; W. 63.8 cm
The Metropolitan Museum of Art, Rogers Fund, 1932
(32.150.32)

This element is part of the arch of the west *iwan* in a house at Ctesiphon. Two bands of unrealistically stylized plant forms, palmettes bound by ribbons, and four-petalled flowers, are divided by a beaded band. The four-petalled floral motif was a popular one over a long period of time and appears in the preceding Parthian period in the stucco decoration of buildings at Seleucia, a city adjacent to Ctesiphon. The rigidly stylized, late Sasanian architectural designs were widely imitated and their

influence is apparent in the architectural decoration of early Islamic buildings in the Near East as well as of early Christian buildings in Constantinople, Armenia, and Georgia.

P. O. H.

14. Ewer decorated with two facing lions

Eastern Iran (?)

about 700

Silver, partially mercury-gilt, repousse decoration

H. 35 cm; Wt. 1,102 g

Paris, Bibliothèque nationale de France, département
 des Monnaies, médailles et antiques, inv. 56.363

This pear-shaped ewer has a small widened foot with a projection in the middle, a narrow cylindrical neck, and an oval opening. The handle is missing and only two traces of the attachment remain: the upper one under the ring separating the neck from the body, and the lower one in the middle of the body. The bas-relief decoration on both sides of the ewer consists of two lions with long curly manes standing on their hind legs, each with an eight-pointed star decorating one shoulder; their bodies are interlocked and their heads are turned to face each other. These two pairs of felines are separated on one side by a blooming, leafy tree of life, and on the other side by two desiccated branches rising from a finely-lined double helix.

M. A.-B

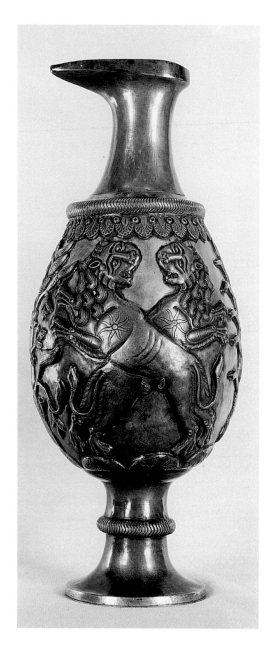

Bálint, Csanad. *Die Archäologie der Steppe*. Vienna: Böhlau, 1989.

Baratte, François and others. *Le trésor de Carthage: contribution à l'étude de l'orfèvrerie de l'antiquité tardive*. Études d'Antiquités Africaines. Paris: CNRS, 2002.

Brunner, Christopher J. "Middle Persian Inscriptions on Sasanian Silverware." *Metropolitan Museum Journal* 9 (1974): 109–121.

Cahier, Charles, and Arthur Martin. *Mélanges d'archéologie, d'histoire et de littérature*. 4 vols. Paris: Mme Ve Poussielgue-Rusand, 1847–1856.

Chabouillet, Anatole. *Catalogue général des camées et pierres gravées de la Bibliothèque impériale*. Paris: J. Claye, 1858.

Charleston, Robert J. *Masterpieces of Glass: A World History from The Corning Museum of Glass*. New York: H. N. Abrams, 1980.

Collingwood, Peter. *The Techniques of Tablet Weaving*. New York: Watson-Guptill, 1982.

Demange, Françoise, ed. *Les Perses sassanides: Fastes d'un empire oublié, 224–642*. Paris: Paris-Musées; Suilly-la-Tour, France: Éditions Findalky, 2006.

Dimand, Maurice S. "Studies in Islamic Ornament," *Ars Islamica* 4 (1937): 293–337.

Ettinghausen, Richard. *From Byzantium to Sasanian Iran and the Islamic World*. Leiden: Brill, 1972.

Ettinghausen, Richard, Oleg Grabar, and Marilyn Jenkins-Madina. *Islamic Art and Architecture, 650-1250*. New Haven: Yale University Press, 2001.

Fukai, Shinji. *Persian Glass*. Translated by Edna B. Crawford. New York: Weatherhill/Tankosha, 1977.

Ghirshman, Roman. *Bîchâpour*. Vol. 2, *Les mosaïques sassanides*. Paris: Librarie orientaliste P. Geuthner, 1956.

———. *Persian Art, Parthian and Sasanian dynasties, 249 B.C.–A.D. 651*. Translated by Stuart Gilbert and James Emmons. New York: Golden Press, 1962.

Gignoux, Philippe. "La chasse dans l'Iran sasanide" *Orientalia Romana, Essays and Lectures* 5. *Iranian Studies* (1983): 101–118.

Gunter, Ann Clyburn. "Ancient Iranian Drinking Vessels," *Orientations* (1987): 38–45.

Harper, Prudence Oliver. "The Senmurv," *The Metropolitan Museum of Art Bulletin* 20, no. 3 (November 1961): 95–101.

———. *The Royal Hunter: Art of the Sasanian Empire*. New York: Asia Society, 1978.

Harper, Prudence Oliver and Pieter Meyers. *Royal Imagery*. Vol. I, *Silver Vessels of the Sasanian Period*. New York: The Metropolitan Museum of Art in association with Princeton University Press, 1981.

Kent, John Philip Cozens and Kenneth S. Painter, eds. *Wealth of the Roman World: AD 300–700*. London: Published for the Trustees of the British Museum by British Museum Publications, 1977.

Marshak, Boris. "The decoration of some late Sasanian silver vessels and its subject-matter." In *The Art and Archaeology of Ancient Persia: New light on the Parthian and Sasanian Empires*, edited by Vesta Sarkhosh Curtis, Robert Hillenbrand and J.M. Rogers, 84–92. London: I.B. Tauris in association with the British Institute of Persian Studies, 1998.

Nicolle, David, and Angus McBride. *Sassanian Armies: The Iranian Empire early 3rd to mid-7th centuries AD*. Stockport: Montvert, 1996.

Pfrommer, Michael. *Metalwork from the Hellenized East: Catalogue of the collections, the J. Paul Getty Museum*. Malibu: The Museum, 1993.

Pope, Arthur Upham, ed. *A Survey of Persian Art from Prehistoric Times to the Present*. Vol. I. London and New York: Oxford University Press, 1938–1939.

Vickers, Michael. "Metrological Reflections: Attic, Hellenistic, Parthian and Sasanian gold and silver plate," *Studia Iranica* 24, no. 2 (1995): 163–184.

Whitcomb, Donald S. *Before the Roses and the Nightingales: Excavations at Qasr-i Abu Nasr, Old Shiraz*. New York: The Metropolitan Museum of Art, 1985.

Whitehouse, David. *Sasanian and Post-Sasanian Glass in The Corning Museum of Glass*. Corning, NY: The Corning Museum of Glass in association with Hudson Hills Press, 2005.

Yoshimizu, Tsuneo, ed. *The Survey of Glass in the World*. Tokyo: Kyuryudo Art Publishing, 1992.

Zerwick, Chloe. *A Short History of Glass*, second edition. New York: H. N. Abrams in association with The Corning Museum of Glass, 1990.

List of Contributors

M. A.-B: Mathilde Avisseau-Broustet, département des Monnaies, médailles et antiques, Bibliothèque nationale de France, Paris

D. B.: Dominique Bénazeth, département des Antiquités orientales, Musée du Louvre, Paris

M. C.: Michael Chagnon, Research Assistant of Islamic Art, Brooklyn Museum, Brooklyn, New York

F. D.: Françoise Demange, Conservateur en chef, département des Antiquités orientales, Musée du Louvre, Paris

R. G.: Rika Gyselen, Directeur de Recherche, Centre National de la Recherche Scientifique (CNRS), Paris

P. O. H.: Prudence O. Harper, Curator Emerita of Ancient Near Eastern Art, The Metropolitan Museum of Art, New York

D. W.: David Whitehouse, Executive Director and Curator of Ancient and Islamic Glass, The Corning Museum of Glass, Corning, New York

Photo Credits